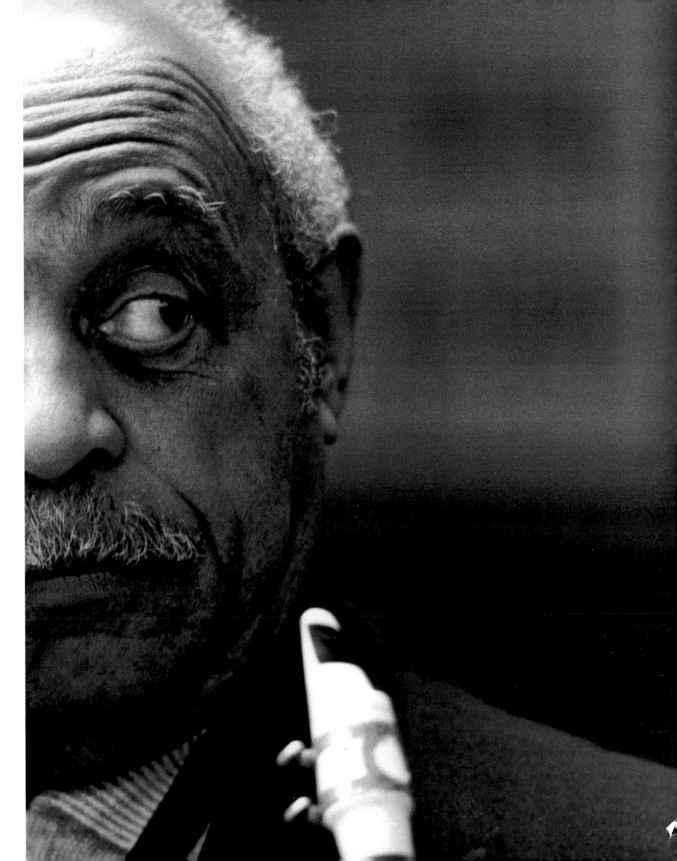

Glorious Days

A Jazz Memoir Herb Snitzer

University Press of Mississippi / Jackson

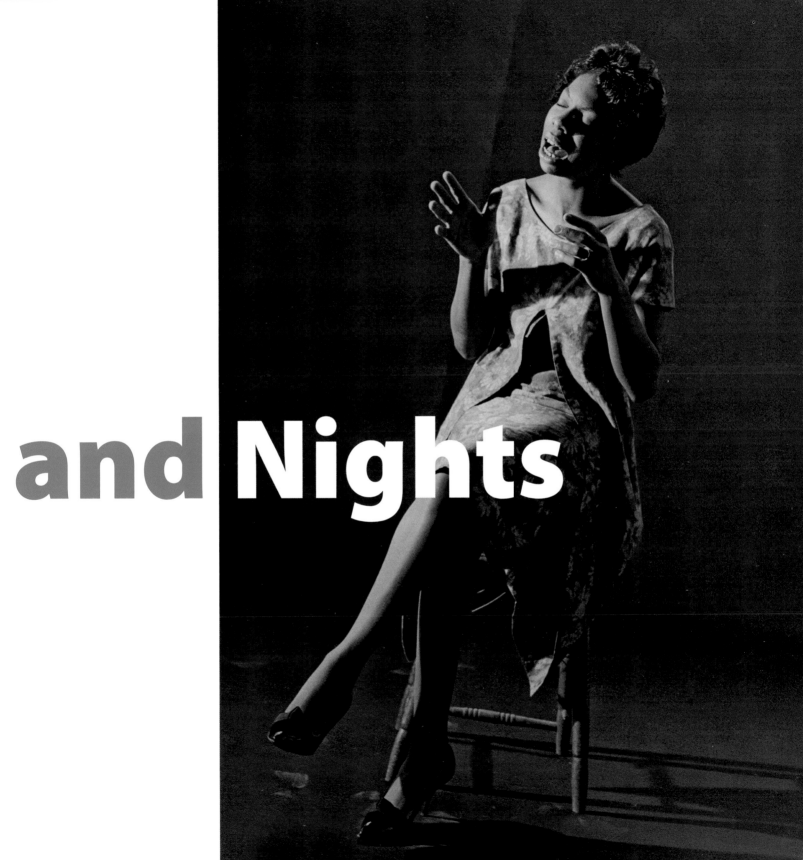

and Nights

www.upress.state.ms.us

The University Press of Mississippi is a member of the Association
of American University Presses.

Photograph on page 1: Saxophonist Benny Carter, Harvard,
Cambridge, MA, 1988

Photograph on page 3: Singer Nina Simone, Philadelphia, PA, 1959

Printed in China through Four Colour Print Group, Louisville, Kentucky

First printing 2011

Library of Congress Cataloging-in-Publication Data

Snitzer, Herb.

Glorious days and nights : a jazz memoir / Herb Snitzer.

 p. cm.

 Includes bibliographical references.

 ISBN 978-1-60473-844-5 (cloth : alk. paper) — ISBN 978-1-60473-845-2

(ebook : alk. paper) 1. Jazz musicians. 2. Jazz musicians—Portraits. 3. Jazz—

Pictorial works. 4. Snitzer, Herb. I. Title.

 ML3506.S65 2011

 781.65092—dc22

 [B] 2010030989

British Library Cataloging-in-Publication Data available

If there is no struggle there is no progress. Those who

profess to favor freedom and yet depreciate agitation

are men who want crops without plowing up the ground;

they want rain without thunder and lightning; they want

the ocean without the awful roar of its many waters.

—Frederick Douglass

Contents

Preface

The early Eisenhower years were filled with contradictions; apathy and bus boycotts, conservatism and radicalism. The middle-class white world was recovering from Joe McCarthy; blacklisted writers were using phony names to get work in Hollywood and London; Jack Kerouac and Robert Frank roamed America; and Roy Cohn remained evil. By 1957, the year I moved to New York, the Montgomery, Alabama, buses had been integrated (December 21, 1956). There were growing signs that black America was no longer going to be continuously embarrassed, no longer going to be content in living second-class lives. This "unrest" as the *New York Times* so quaintly called it, burst upon white America in 1955, when Ms. Rosa Parks was arrested for not giving up her bus seat, setting off a chain of events, reverberating still.

Amazingly, Judge Franklin Johnson, a Republican-appointed federal judge, ruled that his state's busing laws were unconstitutional. A truly brave act on his part. By December 5 twenty-five-year-old Dr. Martin Luther King Jr. was elected president of the Montgomery Improvement Association. The boycott began.

The United States has come a long way in internally destroying attitudes that suggest that an entire race by being of a different color should be enslaved with little or no rights, no protections. Attitudes die hard. Between 1882 and 1955 five thousand lynchings were recorded. There were, on average, sixty-seven blacks lynched each year during the first twenty years of the twentieth century. This fact was not lost on the collective black consciousness, and it found musical expression in the haunting ballad "Strange Fruit," sung by the great jazz vocalist Billie Holiday. "Southern Tree bear strange fruit / Blood on the leaves and blood on the root, / Black body swinging in the southern breeze / Strange fruit hanging from the poplar trees."

There is another rendition of this song sung by the great Nina Simone that will chill the spine. Each version is a testament to the greatness of the song and the singer. In fairness, not all southerners were or are evil; too many, however, in positions of influence, did little to stop the lynchings. Too many doctors, lawyers, and judges of the twenties, thirties, and forties were intimidated by members of the KKK who were also in positions of power and influence. It was a sad time in America.

Much has been written about the unanticipated changes that came about after the Second World War relating to increased racial awareness, the internationalization of black music, sensitivity toward minorities, and so forth. But the dark side continued for many years. In the July 1939 issue of the *Journal of Negro Education*—while Louis Armstrong, Duke Ellington, Cab Calloway, Fletcher Henderson, and other noted black artists were wowing audiences (segregated in the South)—Dr. Ralph Bunche of the United Nations prophetically and chillingly wrote, "Unless the Negro can develop and quickly, organization and leadership, endowed with broad social perspective and foresighted analytical intelligence, the Black citizen of America may soon face the dismal prospect of reflecting upon the tactical errors of the past from the gutters of the black ghettoes and concentration camps of the future." His

use of the phrase "concentration camps" stunned me. The concentration camps of the Nazis were still relatively unknown to the world for another four years. Or were they?

The great jazz trumpet player Miles Davis once remarked that if white America knew what many blacks were thinking it would scare them half to death. Miles was always one for overstatement, but I cannot discount Miles Davis's personal views of white America. If I were black, living within a hopeless or what I perceived to be a hopeless situation, told by the larger society that I was worthless, second best, unnecessary, eventually I would relate to the larger society in ways which were less calm and other than law abiding. Anger and frustration found their way into the music of the 1950s, 1960s, and 1970s: In the words of Langston Hughes, "Old cop just keeps on 'MOP! MOP . . . BE-BOP . . . MOP!' That's where BE-BOP comes from, beaten right out of some Negroes head into them horns and saxophones and piano keys that plays it . . ."

• • •

A special nod goes to two people not directly connected to the jazz world but whose lives were exemplary and whose dreams continue to connect people of goodwill: Marian Anderson and Paul Robeson. Early on they both spoke and sang out for freedom and dignity, equality and self-respect. They are kindred spirits to Louis Armstrong, Duke Ellington, John Coltrane, Miles Davis, and Sarah Vaughan. They have left a legacy that deserves our continuous attention. We owe them an enormous thank you.

I also want to thank my wife, the painter Carol Dameron; thanks to Ed and Gail Snitzer for their unwavering support; longtime jazz friends, Dan Morgenstern and Jerry Smokler; the cultural historian Dr. Benjamin Cawthra, Cynthia Sesso, Gretchen and Barry Singer, Ellen and Burton Hersh, Babs Reingold, and Jim Wightman. A special thanks goes to *New York Times* best-selling author Peter Golenbock, a dear friend and ultimate professional. Many, many thanks.

Introduction

The question hangs out there like gently swaying laundry. "Why am I, a middle-class humanist white guy so engrossed in the world(s) of African Americans and their drive for freedom and civil rights?" My response is always the same: inequality for one is inequality for all. Racial hatred toward one is racial (ethnic) hatred toward all others.

My parents were pogrommed out of the Ukraine by the dreaded Cossacks so many years ago—they are both dead—yet their stories remain as vivid today as when I first heard them. How dreadfully frightened, alone, and small a black child must have felt in those same years at the beginning of the twentieth century, especially growing up in the South where I now live and work. But does this really explain why my commitment to civil rights and liberties and my sustaining love of jazz remain full-blown, as strong now as forty years ago? My overall feelings about justice, equality, freedom, and the deeply held belief in all people being equal were formed in the late forties, early fifties—my teenage years, those days of Emmitt Till, *Brown v. Board of Education,* Joe McCarthy, Martin Luther King Jr., civil rights demonstrations, and marches for freedom, dignity, and equality.

My own personal struggles were less dramatic. Good people were there to help my parents in time of need. Good people were there when I started my professional career in New York City in 1957. I feel I owe the same embracing to others, and since I love art, jazz, photography, freedom—especially freedom—there was and is an obvious connection to the people who make this music come alive and push it forward.

I came to jazz through art—painting and photography, the American Abstract Expressionists, beat poets, Greenwich Village wanderings—as a young and very impressionable artist living in New York City. I was drawn to the music, as I was to my art, initially, by the spirit and joy that I felt every time I heard jazz; this multifaceted and highly original music lifted my soul and spoke to my heart, much as Mozart did, and the initial feelings have not left me. The early to mid-fifties were spent growing, maturing, serving my country in the United States Army (now that was a trip), splitting for New York City the day after I graduated from an art college in Philadelphia.

I was in the Big Apple, the Waldorf Astoria, 52nd Street, the Bowery, the Five Spot, the Half Note, the Village Vanguard, further uptown, Basic Street East, Count Basie's, Small's Paradise, and of course, the Apollo, where every jazz junkie came for a fix in those days. But we don't use language like that anymore. Now jazz musicians bring their Evian water on the bandstand—bubbles without the bubbly.

Living in New York City between 1957 and 1964 provided me with many breaths of fresh air: Pops, Duke, Sassy, Trane, Eric Dolphy, all alive and swingin', along with Nina Simone, Ornette Coleman, Charles Mingus, Stan Getz, Carmen McRae, Coleman Hawkins, Roy Eldridge, John Birks Gillespie, Red Allen. Oh my, the list was almost endless, and they were all great musicians and some of them wonderful composers. I feel badly leaving off so many other names from this list of jazz artists.

And so along with dropping in on the abstract expres-

sionists, enjoying their slashing and dashing, their parties almost as wonderful as their paintings, it wasn't difficult being drawn to jazz; it was all around, you just needed to reach out, it was here, there, everywhere, anywhere, inside, outside, all around.

The forty years from 1955 to 1995 proved to be tumultuous in the life of the United States and in the singular and collective lives of African Americans. Blacks' struggles for freedom and equality make us a better nation; yet knowing full well how fragile and demanding freedom is, one must be vigilant and knock away the forces of totalitarianism and the ugliness of intolerance and prejudice, whenever and wherever these forces appear. They are in evidence today!

This book is about men and women committed to the making and playing of music we call jazz, addressing its development in relationship to the ever-growing freedoms being experienced and gained by people "of color." The vast majority of jazz musicians are black, and they live in a country that was and is, for the most part, indifferent to and unsympathetic to their concerns, aspirations, and dreams, not as musical artists, but as human beings.

In October 1958 I went to meet and photograph Lester Young. From that day (night) on, jazz musicians have been a part of my life. Their music is entertaining and intellectually stimulating, and their lifestyles swingin'. No Chet Baker, no Spike Lee films, thank you. Clint Eastwood's produced "Straight. No Chaser" is where it's at. Simple and honest, no frills, just the action and the jazz artist. So the music is in my heart. One day I might just hear Sassy (Sarah Vaughan) sing again when I close my eyes and listen hard, with Duke's orchestra, and then she, Ella Fitzgerald,

and Carmen McRae will sing a song that lasts forever. That would be something.

Certainly this book is an autobiography, but it also reflects the times, and also I have a lot of strong opinions about things I wish to share. The people in this book were very important cultural icons, and it is my fervent wish that my words and photographs bring them into focus in every way possible.

1 Beginnings

One day after graduating from college in June of 1957, I arrived in New York City to stay. You could park on the streets back then. I had driven my brother Ed's '51 Mercury from Philadelphia up New Jersey through the Lincoln Tunnel to Manhattan's west side, where I rented a two-and-a-half bedroom, fifth-floor walk-up on 70th Street right off Central Park West for $70 a month. I was ready to capture the world.

Getting there had not been easy or fun. I was a child of the thirties, a son of refugee parents who really had no idea how to raise children. They got off the boat and settled in Philadelphia, the cradle of liberty and the home of the Quakers, but I doubt they knew much about that. My brother and I had to suffer through a lower-middle-class insulated Jewish life, where art and music were considered frivolous activities, and where fear and poverty were never far away. I can still close my eyes and picture my father at age four under a wagon in his small village in the Ukraine, as the Cossacks, brutal men mounted on horses, came rampaging into town, shaking not only the ground but the very soul of my father. How dreadfully small he must have felt.

I caught a break when I passed all the tests and was admitted into Central High School, a very prestigious public institution where only the best students from across the City of Brotherly Love were admitted.

Like a lot of kids, I didn't take my high school education very seriously. I was a football player for my first three years—a halfback—and that was how I saw myself. My most vivid memory in high school is of being on the field when our quarterback was injured. The coach sent in his replacement, an Afro-American kid, who trotted onto the field. As he got to the huddle, the coach hollered out to me, "Snitzer, you call the signals." I remember seeing the kid's face. He was upset and embarrassed, though he didn't say a word. Here we were, going to the best high school in Philadelphia, and this kid was just as smart if not smarter than I was. But it was obvious to everyone the coach didn't want him calling the signals because he was black. Looking back, I have to say I was thrilled for the opportunity, but at the same time embarrassed. I slowly became acutely aware of the racism that existed in the world. Eyes open, I began to notice it more and more. Though most whites treated Afro-Americans as if they didn't exist, I found myself drawn to the handful of black kids at our school. I liked their dignity. I felt they had a reserve about them, a kind of maturity the white kids didn't seem to have, and I also respected the black athletes because to get their chance, they had to be better. Jackie Robinson had joined the Brooklyn Dodgers in 1947, but most of the country still didn't get it: there were sensitive, talented people behind those black faces. I'm a little embarrassed to say we never socially mixed—just wasn't done, the times so terribly different, everyone so immersed in their ethnicities. But that incident left its mark, which made me, in time, pursue history, events that shaped this country, its people, and what I discovered saddened, angered, challenged, and changed me forever.

I used to enjoy going to see the Philadelphia Stars, the local Negro League team. Though most of the people in the crowd were African American, with a sprinkling of whites, I had no hesitation about going. I went because it was baseball and because the men on the field were talented players.

At the end of my junior year, I hurt myself playing football, and I didn't play my senior year. I concentrated on my studies instead, and lo and behold, my teachers found out I was pretty smart.

From high school I wasn't sure what I wanted to do. Even though I didn't take it seriously, I knew I liked to draw, and so I went to the Philadelphia Museum School of Art. The school wasn't accredited, and my parents never supported me, but I was head strong, and I pursued the arts anyway. While there, I noticed evocative photographs displayed on the walls, and I bought a cheap camera, and I began to learn how to take pictures and how the darkroom worked. I also began taking weekend trips to see Broadway plays and to visit the great art museums of New York. It didn't cost much, a bus ride and a night at the Y. Back then you could sit in the balcony and watch a great, serious Broadway show for ninety-five cents.

When I was drafted into the army early in my junior year in February 1953, I took my camera with me, making lots of photographs of paratroop jumps and of people in the military. Unfortunately, I don't have any of those negatives.

My military life was nothing to write home about. My most vivid memory was going home to Philadelphia in my military uniform and attending a Quaker meeting. I listened to Senator Wayne Morse talk about his opposition to the Korean War, and there I was sitting provocatively in the audience in my military uniform. Only later did I realize how patient and tolerant the Quakers were of me.

My other army memory came in May 1954. The Supreme Court decided *Brown v. Board of Education* in favor of those who sought integration. I celebrated with a few black soldier friends, who wouldn't take me to a black bar, and I certainly couldn't take them to a white one—being stationed in the South at the time—and so we drove around, sipping drinks, wondering what the hell was going to happen now.

I never got to see the shores of Korea. I was against the war, against violence, but back then there was no draft counseling as there was during the Vietnam War. Going to Canada was out of the question. I was drafted right out of college at age twenty, and every day I hated being a soldier so much I almost drank myself to death. After I began my military career at Camp Pickett near Richmond, Virginia, I moved on to Fort Knox, and then I spent the last five months of my active service in a military hospital in Valley Forge suffering from alcoholism, hepatitis, and cirrhosis of the liver.

After twenty-seven months in the service I received an honorable discharge. I returned to the Philadelphia College of Art and got my degree. I had decided to make photography my life. Every senior had to turn in a thesis, and mine was to photograph the Philadelphia Orchestra. I had always loved music. The orchestra played just two blocks from the college. I went to the administrators of the orchestra and got permission to photograph Eugene Ormandy and his orchestra. I have early photographs of Leontyne Price singing Handel's "Messiah." I took over a hundred photographs, and a few years ago printed a series from those negatives.

I received an A plus on my thesis. I was twenty-three years old. I knew where I wanted to go, back to the museums and the Broadway shows. And so, the day after graduation I revved up the Mercury and headed for the big city.

2 MOP, MOP . . . Bebop

I was new to the city, and I needed a job. I decided the best way to get one was to call up a famous photographer on the phone and ask him if he needed an assistant. I opened the phone book and looked for the list of photographers. This was the era of the national magazines, *Life, Look, Time, Colliers*, and the *Saturday Evening Post*, and if you had talent, you could make a good living. I looked down the list, and I saw the name "Arnold Newman." He was a portrait photographer of some renown, and he had come from Philadelphia. I called him and said I was looking for a job. He asked if I had gone to school, and I told him the Philadelphia College of Art. He asked if I had a portfolio to show him, and I said I did. He asked me to bring it over so he could look at it. He liked the photos I had done of the Philadelphia Orchestra, and he offered me a job as his second assistant. He said, "You can help me lug lights and keep the studio clean, and I will pay you forty dollars a week."

I jumped at it, and during the three months we worked together, I met a lot of very famous people in New York, especially those who lived on West 67th Street, which is where the Des Artistes restaurant is. Newman worked for *Life* magazine, and he photographed Stuart Davis, who

had a studio there; Kim Novak, who lived there; and the prominent writer/playwright Samson Raphaelson, all residents of West 67th Street.

I didn't mind carrying his lights and setting them up. I enjoyed going back after a shoot and working in the darkroom. But Arnold was difficult and demanding, and after three months we parted.

I had noticed a wonderful photograph of Marcel Marceau, the mime, on the cover of a camera magazine, and I took note that the man who took the shot was Robert Ritta. I looked him up in the phone book, and when I saw he lived in New York, I called him cold.

"I'm looking for a part-time assistant," he said. "Come on down."

I went down to his studio on West 56th Street between 5th and 6th Avenues, and I showed him my work. We hit it off, and he offered me a job working three days a week for twenty-five dollars a day. I was making twice as much money and working two days less!

Bob was great to work for, just a wonderful man, and he had a lady friend named Kay who was also his agent. The two of them treated me very, very well. I busted my butt for him.

At the same time I began taking a series of photographs of Central Park. I was living in two photographic worlds, in the world of making a living, the commercial world, but also living in the world of art. At the time I still considered myself an artist, not a photojournalist. I saw photography as an art form, and not a lot of people did. There were no photography galleries at the time. But I felt I was an artist, and so what I was photographing I considered art.

During my two off days I took my work to advertising

agencies and art directors of magazines to see if they would be interested in hiring me or buying some of my work.

The first photograph I ever sold was a shot of the celli section of the Philadelphia Orchestra, where I was shooting down from the balcony. *Madison Avenue* magazine bought it, and they used it to illustrate a story they were working on, and they paid me seventy-five dollars, as much as a week's salary. I thought, *Wow! This is pretty good!*

One of the people I went to see was Edward Steichen, the famous photographer who was the curator of photography at the Museum of Modern Art. Steichen had a reputation for helping out young photographers. If he liked your work, I was told, he would buy a photograph or two and put it in the museum's collection. I figured I had nothing to lose, and I went to see him, at the advice of Grace M. Mayer, his associate.

I showed him my Philadelphia Orchestra photographs and also some of the photographs I had taken of Central Park. He looked through my portfolio, selected two photographs of kids from the Central Park series, and paid me twenty-five dollars each for them.

Not long after that, Kay picked out a photograph I had taken of an older man and a young boy sitting on the beach facing the water. (I don't have the photograph.) She sold it to an advertising agency, which used it to illustrate the benefits of an insurance company.

She handed me six 100-dollar bills! She didn't even take a commission. I couldn't believe it. I figured if people were buying my work, I must have something going for me. I thought to myself, *I gotta do this full time.*

I told Bob Ritta, "I'm going to go into the world and go

for it." Bob gave me his blessing. As I said, he and Kay were wonderful people.

I went out on my own, and I didn't sell another photograph for almost four months.

A friend recently asked me if I was a Beat in those days. I was too young and too naïve to even know what that meant, but I did know I loved jazz and wanted to meet and memorialize the men and women who made this wonderful music.

Here's what I knew about jazz: the twenties, thirties, and forties comprised the swing era, the big-band era, and swing was America's popular music. Swing defined American music both in the white and black worlds. You had Benny Goodman and Tommy Dorsey and Duke Ellington, Count Basie, Cab Calloway, and Fletcher Henderson. America was captured and captivated by swing. Many compositions lasted no more than three minutes following the pattern of the 78s of that time, ideal for dancing. Long-playing records came later and with them came longer compositions. Of course, dance competitions were the rage of the swing era as well, and couples would dance and dance for hours, many hours, until some dropped to the floor in exhaustion. But winning came with cash prizes—at a time when people were dealing with the Great Depression. In certain circles money was hard to come by.

After World War II, there was the emergence of what we now know as bebop. Charlie Parker, Dizzy Gillespie, and Max Roach were among the early stars of bebop. Bebop took the world of jazz in a different direction, and while rock 'n' roll, blues, and rhythm and blues became more popular, jazz became a smaller and smaller part of the total music scene in America. Today jazz is practically invis-

ible. But at the time I was starting out, the jazz phenomenon had not declined. Or at least no one had noticed this was happening. Jazz in 1958 was a happening scene.

In my wanderings from magazine to magazine seeking work, I visited the offices of *Metronome,* a jazz magazine. The magazine hadn't published for a while, but its editor, Bill Coss, hired me on a freelance basis to go the Five Spot Café to photograph Lester Young for its annual yearbook.

The Five Spot Café was in a nondescript railroad flat down in the Bowery. It was the home of avant garde jazz, featuring such musicians as Thelonious Monk, Charles Mingus, John Coltrane, Jimmy Giuffre, Ornette Coleman, and Cecil Taylor. When you walked in, the bar was on the right, and the stage was on the left. There were chairs and tables in the middle and smoke all around. It was dark and steamy, a typical jazz club of the era.

Lester Young had been the central and driving force of the Count Basie saxophone section for many years. He was a sad person, a man who had been continuously hurt emotionally. He was fragile. He went into the army but didn't stay long. Like many other blacks, he was a victim of racism. Life was tough for him.

Lester Young made himself readily available to me. I began to photograph him while he was back in his "dressing room," if you can call it that. It was the room where they kept all the Coca-Cola bottles and the food. I have a photograph of Lester with the big freezer doors behind him, which metaphorically turned out to be a statement about him: Lester Young locked in emotionally. Lester was very kind to me. He didn't ask me not to stand so close or not to photograph. I just know he let me do whatever I wanted to do at all hours of the morning.

Lester may or may not have had a love affair with the great blues singer Billie Holiday but for certain they were soul mates. There is a record of Billie singing and Lester playing ("A Musical Romance,"—Columbia Legacy), and the music is so beautiful it brings tears to my eyes.

Billie died in early 1958. Lester was never the same again. He couldn't live with her, and he couldn't live without her.

Tragically, that photography session was the one and only time I ever saw him. He died six months later on March 15, 1959, at the age of forty-nine. People said he died of a broken heart, that he gave up on life. And he was so talented.

That night Lester was playing for a small but dedicated audience of about thirty or forty people. This was my first jazz assignment, and I went with Bob Perlongo, a staff writer for *Metronome*. Lester was special then and continues to be so today. To me he was more than special; to me he was one of the greatest tenor saxophonists ever. He was my initial experience in a lifelong love affair with jazz. He came out of the darkness, dressed in a long black coat, a buffer against the chilling October air, his pork-pie hat settled squarely upon his head, his saxophone resting easily in its black leather case nestled under his arm. By the window light of the café I made the first of many photographs that evening.

The back room quickly filled with other musicians, friends, hangers-on, all wanting to talk and share the moments with Lester Young.

That evening, inside the Five Spot, both backstage and on the bandstand, Lester was smooth, relaxed, and accessible. He joked with the awestruck young members of his band, but they and we all knew he was not well, his health slipping, no one quite sure how long he would live. Prez

played beautifully, sometimes haltingly, never sloppy. He was in the present, teasing his fellow musicians, leaping over their musical lines, pushing them sometimes beyond their musical limits; the always respectfully attentive audience witnessed his musical thoughts and journeys and shared a deep appreciation of the man and his music.

That night's event ended around three in the morning. The experience changed my life. Artists have life-changing moments. For me, this was it. I had never heard a jazz musician up close like that. I just felt I was not in that room, but somewhere else. I could feel it in my chest—my own awe-inspiring, life-changing moment.

I talked to Lester a little, although I was in such awe I really didn't have much to say, but I made pictures that have lasted over fifty years. I took perhaps a hundred and twenty photos, and *Metronome* published a whole spread in their 1959 yearbook. That first negative I ever made of a jazz musician has turned out to be what writer Nat Hentoff called "the quintessential Lester Young photograph." Coming from a man who has seen thousands of "Prez" pictures, the comment is graciously received.

That experience was the beginning of a forty-year odyssey, taking me to other cities and countries, into homes, apartments, concert halls, dark clubs—clubs long closed, worlds of men and women of all colors, nationalities; some of the folks loving, compassionate people, others as nasty as you can imagine, with terrible chips on aggressive shoulders ready to tear down rather than build up, ready to believe that all white folk are bad, ready to do battle where none exists.

3 My World of Jazz

That night with Lester Young was transformative in more ways than one. His playing had spoken to my heart and made me want to know more about his music called jazz. I was new to it, and my reaction was totally unexpected. I had gone as a photographer. I didn't even know who Lester Young was or what his background had been.

When I walked into the offices of *Metronome* magazine looking for work, I had no idea of its history, either. The magazine had started around the turn of the century, featuring marching band music and musicians such as John Philips Sousa. Then came the jazz age, and it covered that, and its circulation was at its zenith during the big-band era, when it wrote about Benny Goodman and Artie Shaw and the Dorsey brothers. It had gone out of business in the early 1950s, until businessman Bob Asen bought it and brought it back to life. Asen himself had been a musician, a saxophone and clarinet player, part of the Dink Rendleman and his Alabamians Orchestra in the 1920s. It was not a very famous band.

Bill Coss was *Metronome*'s editor and Bob Perlongo, who wrote the piece on Lester Young, was associate editor. That's it. Those two were the entire staff, and after they published my photographs of Lester Young, I continued my freelance career.

In the early winter of 1960 I received a phone call from Bob Asen, who asked me if I would like to come on board as photography editor and circulation director. The job paid one hundred and twenty-five dollars a week. You could make a living on that kind of money back then. I accepted.

Because I had two jobs, I ended up working about seventy hours a week. During the day I worked at raising the circulation and bringing in advertisers. At night I roamed the city going to the clubs and photographing jazz musicians. My day began at nine in the morning, and sometimes it didn't end until six the next morning.

Not that I complained. This was the Golden Age of Jazz, and I was given the opportunity to hang out with the old masters like Duke Ellington and Count Basie, and I was also there to see the young turks coming in like Miles Davis and Ornette Coleman. One night you could listen to Nina Simone at Town Hall, and the next night you could see John Coltrane. I also got to play ping-pong with Thelonious Monk at the home of the Baroness "Nica" de Koenigswarter, an heiress to the Rothschild fortune.

Metronome resumed publication in June of 1960 after a long hiatus. On the cover of the first issue was a photo I made of Coleman Hawkins. He was easily recognized by jazz aficionados, so we thought we'd put him on the cover.

Hawkins had originally played with and was a star of the Fletcher Henderson Orchestra from 1924 to 1934. He was in good company in 1932. Others in the orchestra were trombonist Dicky Wells; trumpeter Henry "Red" Allen; saxophonists Hilton Jefferson, Ben Webster, and Don Reman (arranger as well); and clarinetist Buster Bailey. He went to Europe until 1939, playing with the Jack Hylton Orchestra in England, and in 1937 appeared on a recording with saxophonist Benny Carter, guitarist Django Reinhardt, and violinist Stéphane Grappelli. The war in Europe started September 1, 1939. He wisely returned home. He then went off on his own and freelanced for a long time. Hawkins had a great relationship with Roy Eldridge, the great trumpet player whom Dizzy Gillespie saw as a mentor. I was told that when Coleman Hawkins was away from the jazz world that he basically listened to classical music, especially the symphonies of Beethoven. And why not?

The photo that appeared in *Metronome* was made from a sharp angle, because Coleman was on stage playing, and I was down below shooting up at him.

The painters of the fifties, including Jackson Pollock and Stuart Davis, were drawn to the clubs of Greenwich Village where bebop, the new jazz, was being played, where blacks and whites came together in racial harmony or at least in racial tolerance to each other. It's not hard to see why they were drawn to bebop with its dazzling speed and seemingly random, always electrically charged sounds. The musicians were doing in their way what the painters were doing on canvas. Each tried new techniques coming out of a time when America was transforming, when technology was slowly replacing tools, where computers were being introduced, where the norms of society no longer held the culture together.

The painters listened to and absorbed what they were hearing. Stuart Davis's work related to the industrial power of America and the continuous growth and change that came after World War II into the 1950s, twenty years of unparalleled power, and if ever a music reflected this growth and power, it was jazz. The great jazz venues—the Five Spot, the Half Note, the Jazz Gallery, the Village Vanguard—all were downtown New York, the same neighborhoods where the artists hung out. How could they miss each other? The fact is, they didn't.

Thelonious Monk was a big part of that early bebop scene. He was distinct and unique and a very creative jazz pianist and composer. He had the reputation for being

very strange, into his own world. He would stay in bed all day, or he wouldn't talk to anybody. In those days he was what we called "a character." But Thelonious was a highly talented character who could really play.

The first night I photographed Monk, he was playing in the Randall's Island Jazz Festival on a bill with Duke Ellington. That night he wore a Chinese coolie hat. Why? Who knows, but I have these wonderful pictures of him performing with his hat. The next time I photographed him was at the United Nations. Bill Dixon, who worked at the U.N., also was a jazz trumpet player, and he arranged to hold a series of concerts there. They were held in a long hallway where they set up chairs. We sat on the same level as the performers. They brought in a piano and they hired Thelonious Monk to come and perform. On this day in deference to the United Nations, he didn't wear one of his hats inside the building but instead dressed formally and wore sunglasses.

I was one of two photographers there. Unlike today, when it is difficult to get real close to the performers, I was able to set up right on the other side of the piano. Monk was playing and I noticed the piano keys reflecting in his sunglasses, so I started shooting, trying to get the keys positioned just right, and that's how that photo came about. After all these years it's still a wonderful picture. When you say Monk, you picture the glasses. Buell Neidlinger was on bass, Charlie Rouse on tenor saxophone, Monk on piano, and Art Taylor on drums. Ornette Coleman sat in the front row intently listening. It was a terrific afternoon.

During the day my job was to raise circulation and money for the magazine, a job I came to with no prior experience. It was all on-the-job training. The magazine had a mailing list from its previous life, and I wrote letters to former subscribers, apologizing for going out of business, letting them know we were back in business, and asking them to subscribe again. To sign up advertisers, I met with executives from hi-fi companies, saxophone manufacturers, and drum makers like Zildjian.

After a few months I could feel we were making progress. *Metronome* was a good jazz magazine, and subscriptions began to rise, albeit slowly.

Meanwhile, I had access to all of the jazz clubs all of the time. My life didn't have enough hours. That first year Bob Asen, the magazine owner, said to me, "I want you in the office at nine o'clock in the morning." I said, "I'm out photographing until three in the morning. I need my rest." He said, "You're part of the magazine, and I want you at your desk at nine." As a result, I burned the candle at both ends for a while, but even at age twenty-six there was a limit to my energy. I started going to bed earlier.

I went to the Five Spot to photograph Charles Mingus, who was a musical genius and a great composer. In the eyes of many he was the next best composer to Duke Ellington. Mingus was very demanding, and he could be difficult. I never engaged him. I kept my mouth shut, and I made my photographs. I can recall I was at a rehearsal when another musician, a white musician, looked at the musical score they were playing and said, "We have to get the kinks out of this piece." In Mingus's mind, the other musician was making a reference to kinky hair, and he felt it was a racist comment. He picked up his bass and walked out. I rather doubt the other musician's reference had anything to do with kinky hair, but that's how sensitive Mingus was. His legacy is secure. His widow, Sue, is still out there with a big band playing his music.

It was thrilling meeting the jazz greats for the first time. I can remember the first time I photographed Count Basie at Birdland. The Basie band played there a lot. You went down a bunch of steps into a very dark area, meeting Pee Wee Marquette on the way, he almost as famous as the club. The bar was on the left and the seats were on the right. There was an entrance fee, but they let underage kids in who would sit at the bar and drink cokes. After Basie arrived, I walked up to him and shook his hand and told him I was there representing *Metronome* magazine. He was very accessible, and the guys in the band were terrific. They didn't have the ego and the histrionics of the rock 'n' roll musicians of today. I can remember one very special night when the Basie orchestra was playing, and Sarah Vaughan was in the audience just listening. She was wearing a plain dress with a shawl over her shoulders. O. C. Smith, the singer for the Basie band and now a minister in California, kept egging Sarah to come up and sing with him. She kept saying no. She didn't have a gown on, and she was very conscious of what she was wearing. O. C. kept it up, and so she finally got up on stage and they began to sing, but in thirty-two bars, she wiped him out to the point where the band was having trouble keeping the song going because the musicians were laughing so hard. Musically she just whipped his ass. She went off on runs with her sensational voice that made him seem like a teenager. Very quickly he got her off the stage. "Thanks, Sarah, it was great having you up here." Meanwhile, O. C. had egg on his face because she had simply wiped him out. And at that point everyone was cracking up. O. C. learned a lesson. Don't mess with Sassy.

Many of my photographs of Basie were taken at Birdland, but I also was with him at recording sessions for Roulette Records. I attended some band rehearsals, where I made one of my favorite photographs of the hands of Eddie Jones around the neck of his bass. And then there was the session where I met Sammy Davis Jr., when he was recording with the Basie band, and I was able to make one of the definitive Sammy Davis photographs.

Sammy Davis was courteous, very professional, and if he hit a wrong note during the recording, he'd stop and start all over again. He was very demanding on himself. I had a great afternoon. When I went to see these performers it was almost magical. I'd float into their lives, stay for two or three hours, and I might not ever see them again.

The September 1960 issue of *Metronome* featured a half-page photograph of mine of a really far-out pianist by the name of Cecil Taylor. Cecil hit notes that just didn't sound right. Over the years, of course, it turned out Cecil was right and everyone else wrong. But his early music confused people because he hit notes no one ever touched before. He would do it with his elbow, and everyone would say, "He's just hamming it up." But though they were the right keys, they would sound dissident and strange. It was like what happened with the classical musicians who were breaking away from the baroque era and were getting more and more into the music of Beethoven and the contemporary players of the day. The music sounded strange, like when John Coltrane first came onto the scene. Now his music is part and parcel of jazz history. The same thing happened to Cecil Taylor. He was really out there. I have to say I really didn't understand his music. I only met Cecil for an afternoon, and the picture that appeared in the magazine was shot through a window. He was sitting in a diner, and I photographed him through the window. So what you see is the reflection of buildings

in the Broadway area, and street life partially hiding his face. It's a very abstract photograph. Since I felt separated from his music, I tried to get the same feeling in my portrait by shooting through that window as if to say, "The window is a barrier between me and Cecil in understanding his music." I wanted to have a barrier between the two of us.

With all due respect to Taylor, I quote from Ted White's article: "The place of pianist/composer Cecil Taylor in today's jazz is a curious one. His records are few . . . and he has been bitterly denounced by some critics. His music is 'far out,' in that it often meets unaccustomed ears, but can be, in its own way, as exciting and fresh as Ornette Coleman's."

One of the greatest nights of jazz I can recall came in August 1961 at the Village Gate, which was owned by an impresario by the name of Art D'Lugoff. Art was in his early thirties. He had graduated from NYU, worked as a waiter in the Catskills, and drove a taxi. He went on to temporarily manage Nina Simone and Tom Lehrer. He backed a Calypso group called the Tarriers, who had a huge hit with the Banana Boat Song, "Day-oh." Art invested the money he made in the Village Gate. That night in August 1961 was the first of two successive weekends of music by the John Coltrane Quartet, the Horace Silver Quintet, and Art Blakey and the Jazz Messengers with Wayne Shorter on tenor saxophone, Freddy Hubbard on trumpet, Cedar Walton on piano, Curtis Fuller on trombone, and Jymie Merrit on bass. It was an all-star happening. Coltrane added Eric Dolphy to his two-bass quartet. One rendition of "My Favorite Things" was clocked at 35:15 minutes—the length of an average LP. Horace broke it up with his composition of

"Filthy McNasty." The place was half full when I was present. It cost a buck to get in, a beer was fifty cents, and hard liquor a buck and a half—so how much was John Coltrane making? He was lucky if he even got paid. Historians talk about the Golden Age of Jazz. I think back to the Village Gate, half full with three of the greatest artists in the history of the music performing to empty seats. The people present were electrified by what they heard and saw.

My photographs appeared in a two-page spread in the November 1961 issue of *Metronome.*

Of all of the performers, John Coltrane made the greatest impression. He started out playing the tenor saxophone; when he switched to the soprano saxophone he made some of the most significant jazz recordings ever made. Max Roach used to say when he was listening to young players wanting to make an impression, "Man, that cat is playing a lot of notes, but he isn't making any music." John Coltrane was making music. Ira Gitler, a wonderful jazz writer of the day, called Coltrane's efforts "sheets of music." As already mentioned, Coltrane and his group would play for over thirty minutes on one composition. Just having the energy to do so is breathtaking. In addition to having Eric Dolphy on bass clarinet that evening, Dr. Arthur Davis and Reggie Workman were on basses, a young McCoy Tyner on piano, and Elvin Jones on drums.

At one time Coltrane had been a drug addict. For a while he was a mystic. After he got off the junk, he became a compelling musical force. And yet, when I met him, I was impressed by what a gentle person he was. When he finally beat his addiction, he wouldn't even drink in the clubs. He would have hot tea between sets. He lived in a world within himself. He was calm, but when he put that saxophone to his mouth, the music was inspiring. It

moved me in a strange and compelling way. I took it all in. I didn't even question it. It was just what it was. And when I listen to those original recordings, which you can get today on CD, you have to say to yourself, "My God, this guy was a giant of an artist." Coltrane died young.

Bill Coss, *Metronome*'s editor, was the one who came up with the idea of having a ping-pong tournament for jazz musicians. *Metronome* would sponsor the tournament, and I would photograph the games. We set up tables at the Jazz Gallery, a club on St. Mark's Place just around the corner from the Five Spot, and we were able to get Max Roach, Abbey Lincoln, Milt Jackson, and Thelonious Monk to enter the tournament. As I photographed them playing, I took notice that Thelonious Monk, who stood six feet two and weighed about 240 pounds, was head and shoulders better than the others. They weren't athletes, and after I finished taking my photographs, I picked up a paddle and played a little doubles, teaming with Max Roach and then with Abbey Lincoln. I thought to myself, "I'd really like to play Monk. I think I could beat him." I put the challenge to Thelonious one night after he finished playing at the Jazz Gallery. We arranged a match. Baroness Pannonica de Koenigswarter, who loved jazz, was a benefactor of Monk. Before that, she had been a benefactor of saxophone legend Charlie Parker, who died in her New York City apartment. I don't know whether she still had the apartment, but on this night she had brought Monk to the club in her Rolls Royce and was waiting to take him back to her house in Weehawken, New Jersey, overlooking the New York skyline. At 2:30 in the morning I followed in my Volkswagen bug as we sped through the Holland Tunnel to her home.

When we arrived at her home, I walked in and noticed she had set up a ping-pong table in one of the many rooms. Thelonious and I grabbed paddles, and we began volleying. I thought, "I'm going to be able to take this guy." We played the first game, and Monk won 21–8. He cleaned me out. I figured, "Damn, I'm not going to let this happen again. I know what to do." I figured I'd slice more and make him move around. I figured I could out-position him. We played a second game, and this time he won 21–11. He was so fast and quick, I didn't have a chance. I said to him, "Play another one, Monk?" This time he beat me 21–6. By this time it was six in the morning. We put our paddles down, and the baroness brought us coffee and cookies. We chitchatted for a while, and then I got back in my car and headed back to Manhattan. It was a great evening, so much fun. But it seemed unreal that such a big guy could beat me at ping-pong. It was humbling.

4 On the Bus with Pops and Duke

The truth of the matter was that basically none of us running the magazine had the slightest idea what we were doing. Would writing stories about young black musicians help our circulation? We had no idea. We didn't take surveys. We had no business plan. We were a bunch of kids in our mid-twenties flying by the seats of our pants. And it seemed to be working. We were so naïve we went balls open without regard to how we might be received.

Some of our subscribers, those who were used to seeing white faces in the magazine, wanted to know why

there weren't more stories on the reigning white stars like Benny Goodman, Woody Herman, or Maynard Ferguson. They had very little knowledge of Max Roach or John Coltrane. Dizzy Gillespie was, however, a well-known jazz player and performer. Despite the complaints, we were intent on staying with what we were doing because we felt that this was the cutting edge of American culture.

The Montgomery bus boycott took place in 1955, and the Supreme Court adjudicated it in 1956, ruling that blacks deserved equal treatment in public transportation between states, and then came the march on Montgomery, and we were all young enough and impressionable enough and liberal enough to be influenced by the bravery of the men and women who stood up to the white bigots. We saw a direct connection between these emerging black artists and the emerging new culture that one day would lead to the end of Jim Crow. On some level, we said to ourselves, *This is our mandate. This is how we can contribute to the movement, and this is what we're going to do.*

The new editor Dave Solomon was as adamant about this as anyone. He just didn't pick up on the clues from Bob Asen, who said, *"Hey, let's do something else as well."* Bob wasn't objecting to our focus on the young black musicians, because he was a musician himself, and he could understand this transformation that was taking place in the jazz world. He just wanted the magazine to be more like *Downbeat,* our competition.

I didn't say anything, but I sided with Dave. Covering the jazz scene in New York in the late 1950s was electric.

One of the great evenings was opening night of the Ornette Coleman quintet at the Five Spot. The place was absolutely jammed. You couldn't move. In the audience that first night were Thelonious Monk, Leonard Bernstein, and a whole raft of jazz musicians who came out to hear this young soprano saxophonist from Texas with a reputation for making music in a way that had never been done before, free-form jazz music. It was so democratic in the way they went about it, it seemed as if there was no structure to what they were doing. Adding to the mystique was that Ornette played his music on a plastic white saxophone that looked like a toy. With him were Don Cherry, whose little trumpet also looked like a toy, Buster Williams on drums, and Charlie Haden, a bass player who eventually became as famous as anyone in the jazz world.

The Ornette Coleman quintet was booked for two weeks, and they stayed four months. The word went out, and the place was jammed every night. The group came on every night, and the music coming out of these young men was unbelievable. It was like a breath of fresh air. I spent a lot of time with them, going to see them sometimes five nights a week, making sure I caught part of their session. The tragedy for me is that I don't have any of those negatives. I have no idea what happened to them. My whole Ornette Coleman file is gone.

I became friends with Ornette. We were the same age. We took to each other as two creative guys, he with his jazz, me with my photography. He invited me to the group rehearsals, and I took one photo of him and his group in casual clothes that appeared in the December 1961—and last—issue of *Metronome.* Usually when they performed, they got all dressed up in suits and ties and white shirts.

I stayed friends with Ornette for a long time, and then life took its turns, and we went our separate ways.

I spent a great deal of my time in the Village covering the jazz people who were in town performing. I'd go

from Ornette playing at the Five Spot to Basin Street East, a much more upscale club where I saw Ella Fitzgerald, Peggy Lee, Quincy Jones, Lenny Bruce, and Billy Eckstine.

I also got to cover the Newport Jazz Festival, where one year I slept on the beach alongside Pony Poindexter, a soprano saxophonist, "as my guest." We didn't have a place to stay, and everything was booked, so we took sleeping bags and slept under the stars next to my camera equipment.

New York City was teaming, not just with music, but with politics and social change. When I lived in New York there were no photographic galleries. If we wanted to show our work, we had to show them in coffee houses. My first exhibition was at the Ninth Street Coffee House in the mid-forties, where I would go to hear the Beat poets when they were in town. I saw Gregory Corso and Neal Cassady, and I'd also go to the Seven Arts Coffee House, where I met Robert Penn Warren and Mort Sahl.

One of the other great jazz venues was the Apollo Theater in Harlem. I had no fear about getting on the subway and going up to 125th Street with my equipment on my shoulder. That's where I first photographed Miles Davis, backstage, in 1960. They knew me by then, and I could come and go as I pleased. Miles was up and coming, and he had a great group that included Paul Chambers on bass, Jimmy Cobb on drums, John Coltrane on saxophone, Cannonball Adderley on alto saxophone, and Wynton Kelly on piano (tragically dead at forty years of age).

Miles Davis was an innovator. He wasn't such a nice guy. Even when he was starting out, he was difficult, but when he and his group started playing, I started shooting. Miles seemed reasonable with me early on. And once again, when he started playing, the music really resonated with me. It was music like I had never heard before. It really got through whatever defenses I had. I couldn't wait to hear Miles. His music just did something to me, like the first time I heard the Beethoven violin concerto as a kid. It just knocked me out.

What I recall about that first performance was that Miles played it very straight. He looked very conservative, with short hair and wearing a conservative suit with a white shirt and tie. He wasn't interested in theatrics. He just played his music. I don't recall having any interchange with him. I stayed at arm's length.

I also got to spend a bit of time with LeRoi Jones, who later changed his name to Amiri Baraka. We were about the same age, and I met him at one of the clubs. He was married to Nettie, a white Jewish woman. LeRoi was trying to make his mark. I was trying to make mine. It was like what Cynthia Ozick says, "You become part of the nerve of your generation." That's what we all were doing—unbeknownst to us. We weren't so philosophical about it.

One of his plays had been published, and I hung out with him in their apartment. It wasn't special. It was in the course of living. I tell people, when you're in New York, you can walk down the street and see all kinds of famous people.

One of the highlights of my time at *Metronome* was my road trip with Louis Armstrong, whom everyone in the business called "Pops." The public called him "Satchmo," but none of his friends ever called him that.

We knew that Pops was going up to Tanglewood to perform, so we called his manager, Joe Glaser, to see if we could come along for an article in the magazine.

Joe Glaser and Joe Kennedy were part of the Mafia. The Kennedy connection to the Mafia is well documented

in a recently published book on Bobby Kennedy and FBI director J. Edgar Hoover, by Burton Hersh. These guys used to run booze down from Canada during Prohibition, and when that ended, Joe Glaser had contacts with every nightclub and gin joint in America. He became the head of ABC Booking, the biggest booking agency in New York. Joe managed Louis Armstrong.

As you can imagine, no one screwed with Louis or tried to cheat him out of money, because they'd have to answer to Joe Glaser. I have a wonderful picture of Joe Glaser talking to Trummy Young, Louis's trombone player.

Two days before the trip, I went to see Trummy Young, wanted to get to know him, so I would have a contact when I showed up for the trip. I also wanted Trummy to introduce me to Louis.

Trummy and I had a nice chat, and I said, "I'll be up to Queens in a couple of days," and we shook hands. When I arrived at Louis's house I didn't feel alone.

I saw Trummy standing outside the bus, and we shook hands and talked. Louis came out of his house, down the steps, and he walked over to Trummy.

In that deep, gravelly voice, he said good morning to Trummy, and they talked jive, "Cool, cool," and I just stood there in awe. Louis turned to me and said, "Good morning," and I fumfetted and hemmed and hawed, until I could finally get it out: "Good morning, Mr. Armstrong." Trummy, meanwhile, was cracking up. Pops smiled and turned and got on the bus, and I thought to myself, *Jesus, what a schmuck you are.*

We got on the bus and headed north toward Connecticut. This was no Greyhound. It was a yellow school bus with no air conditioning, no bathroom facilities, and rigid seats that made it impossible to sleep during our trip back in the middle of the night.

After we reached Connecticut, Pops had to go to the bathroom. We stopped, and he went into a restaurant. When he asked where the bathroom was, he was told the bathroom was off-limits to blacks. I guess they didn't recognize him. But as Pops walked back to the bus, a car screeched to a halt and a couple of college kids ran over to him to get his autograph. Racism was nothing if not inconsistent.

When he returned to the bus, he was furious. I had not yet seen a look like that on his face. To make Pops furious was doing something, because usually he was so mellow.

I will never forget the look on his face. The most famous entertainer in America, and he couldn't use the bathroom because he was black. This only reinforced the political and social ideas I was forming.

We stopped at another place, and he went to the bathroom. He got back on the bus, and the bus started up, and it was at this point that I made my most famous Louis Armstrong photograph of him holding a cigarette, his white shirt open, and you can see a Star of David hanging around his neck.

Louis stared straight ahead, not saying anything as I took pictures. I then went back and sat with Trummy, and I took some pictures of Trummy and Barney Bigard, the great clarinet player in the group. Later on, his singer, Velma Middleton, a large woman, stood up on the bus and fell. She was in pain, and we were afraid she had broken a rib. Everyone talked a long time about how to find a doctor, but no one did anything. When the bus arrived at the site of the concert, the show went on as scheduled. Velma never did see a doctor.

When we got to Tanglewood, Louis changed into his tuxedo and patent-leather shoes, and it was a whole other world. Pops was treated as royalty, and when he came out

and played in the old, small Tanglewood bandbox, he was in his glory. I made a series of six pictures of Velma dancing, and from that one evening I made a series of photographs that are going to live forever.

The picture of Louis Armstrong wearing his Star of David has become iconic. Photography in general, and my work in particular, creates a story. When the viewers see the photo, they want to know under what conditions the photograph was made and who was there. In this case they want to know, *Why is he wearing a Star of David. He wasn't Jewish, was he?*

No, Armstrong wasn't Jewish. But when he was a child, he was befriended by a New Orleans Jewish family, the Karnofskys. He didn't know his father. His mother was a prostitute. He was on the streets when the Karnofskys took him in, fed him, clothed him, and gave him a place to stay because they saw this young talent. One birthday they gave him the Star of David, and he wore it his whole life. He was buried with it.

When I knew and photographed Louis Armstrong, he always had an integrated band, and it's my contention that Louis found a way to pay the Karnofskys back by always having a Jewish bass player. He had Jack Lessberg, and then he hired Mort Herbert, who was on the bus with us that day. Was that accidental? Was "Pops" feeling the civil rights movement of the time? Was he in sync with it? Yes, I am going out on a limb, but Glaser? Herbert, Lessberg? Accidental? Maybe so, but then again, maybe not.

Louis Armstrong, like Miles Davis, didn't care what color you were. All he wanted to know was, *Can you play?* When Miles hired Bill Evans to play the piano, he got static from some of the members of his band. Miles said, "You find me a black piano player who can play as well as Bill Evans, and I will hire him." And that was the end of it. Miles

didn't give a damn about color, and Pops was the same way.

Later I had a photo session with Trummy Young, who invited me to come see him in his apartment in a hotel on Times Square. I walked down the hallway leading to his room, and I could hear him playing scales. Now Trummy Young is regarded as one of the best trombone players of all time. I knocked on the door and went in, and I said, "How long have you been practicing?"

He said, "About two and a half hours."

I said, "You've been running scales for two hours?"

He said, "Herb, Pops pays me very well. If he heard me being sloppy, that would be the end of it." So even with all the shucking and jiving Pops was doing, you had to play. Pops was a serious musician, and he didn't want you fucking up. So there was Trummy, one of the greats, playing scales, making sure his chops were right up to where Pops wanted them to be.

That's the musician side of Louis Armstrong. Pops really enjoyed performing. He really enjoyed making music. He was such a joyful man in his own right, but he was also a demanding leader. He paid his people very well, and in return he expected them to be serious about their music.

The last time I saw Louis Armstrong was in a restaurant around the corner from the *Metronome* offices called the Copper Rail. It was a hangout for black jazz musicians on Broadway.

I was sitting at the counter eating a soul food dinner. After the meal I planned to head to some clubs. I was chowing down when Pops walked in and sat down right next to me. It was very unusual for him to be just hanging out in the city.

He recognized me from our bus trip, and we shook hands. "How you doing, Pops? Nice to see you." Once he

sat down, I decided I wasn't going to move, even if he sat there all night. It was a good thing I didn't have to go to the bathroom.

Once Pops sat down, the word got out. Other musicians started to drift in, and the place filled up with people having fun and joking and laughing. When jazz musicians get together, it's like a carnival.

It was a hot night. The little fan over the door didn't do much. I can't say Pops and I had dinner together, but it was so joyful. You could feel the love coming from everybody, from the men and women who were there. I didn't have my cameras that night!

Louis Armstrong was an extraordinary artist, and he single-handedly changed American music. He made the solo important, and central, and we have not come off that dime since. This one man transformed American music all by himself. He grew up during a time of segregation and racism, and who knows what he could have done had he been in an era where this no longer was important.

It was a real honor to know him.

Another time I rode the bus with the Duke Ellington orchestra. They were playing at the Westbury Music Fair out on Long Island, so it wasn't a very long trip, but it was memorable nevertheless.

I first met Duke at Randalls Island in 1959. He was born in 1899, so he was sixty years old, and at that age he was still a very handsome man. I've seen pictures of him when he was in his twenties. He must have been very popular with the ladies because he was not only attractive, but he was also very creative, the perfect combination for attracting women. I remember that Duke wore a jacket made of upholstery material. It was fall, and he wanted to be warm.

That night when I photographed him, very few pho-tographers came and you were allowed to get very close, so I was able to walk to the edge of the stage and shoot up at him while he was performing. I doubt that he was more than three feet away from me. I made a whole series of photos of him, and then I didn't see him again until I took that bus ride to Westbury.

To my mind, Duke Ellington is the single greatest American composer, outshining George Gershwin or Irving Berlin or Leonard Bernstein. Bernstein was in awe of Duke Ellington.

Duke never won a Pulitzer Prize for music. The story goes that when he was passed over by the Pulitzer committee, Duke said, "Fate has been very kind to me. Fate did not want me to be famous too young." The jazz critics were in an uproar, with both Ira Gitler and Nat Hentoff writing scathing pieces supporting Duke.

Duke wrote over twenty-five hundred compositions. I once had a conversation with a music critic. I said, "Look, the reason Ellington isn't rated with Gershwin and Berlin is his music isn't Eurocentric."

"What does that mean?" he asked.

I said, "He doesn't use cellos and violins. If he would have used cellos and violins instead of trombones and saxophones, Duke would have been played on every classical music station in America. But if you transcribe his music, which people have done, into European instrumentation, you would see the greatness of his compositions."

Duke would compose on Tuesday night, and on Wednesday morning the orchestra would be rehearsing the compositions he had written the night before.

Duke's orchestra—I never called it a band—was one of the finest groups to come together and play. He had Johnny Hodges on alto saxophone. Ellington composed

a piece called "Jeep's Blues" for Hodges, whose nickname was Jeep. He had Paul Gonsalves on tenor saxophone, Jimmy Hamilton on tenor saxophone and clarinet, Clark Terry on trumpet, and Juan Tesol on trombone, among others. Sam Woodward was on drums.

Duke was a pianist and a very good one. Duke would play the piano and lead the orchestra from behind the piano. Duke had led his orchestra from the time he was eighteen years old. He came from Washington, D.C., part of the black middle class of the city. His parents wanted him to be a doctor or a lawyer, but all he wanted was to play his music. By the time I first met him, a lot of the other orchestras were going out of business. Rock 'n' roll was coming in, and it was getting harder and harder to pay the salaries of so many men. But Duke was able to keep his orchestra together because of the royalties he made from writing his compositions.

The other event that sustained his orchestra was a concert it performed at the Newport Jazz Festival in 1956. I wasn't there, but everyone who had an interest in jazz heard about it, and fortunately the concert was recorded. The orchestra was playing, and Duke called out, "The Diminuendo in Blue and Crescendo in Blue." In between was an interlude by Paul Gonsalves on the saxophone. When they hit the break, Gonsalves played fifty-six choruses. He went on for almost thirty minutes, and while he played the sedate white audience got up and started dancing in the aisles while many other spectators rushed toward the stage.

At the end everyone was going crazy, and when Paul finally stopped, Cat Anderson, the lead trumpet player, began playing these high E notes, at which point the place went wild. Everyone was shouting and screaming, and

Duke was saying, "We got lots more. We got lots more." But Duke didn't have lots more, because the man who ran the festival, George Wein, was so afraid there'd be a riot that he asked Duke to calm things down. It must have been thrilling to be there.

So when I got on the bus for the ride to Westbury, I was in total awe of him. I sat with Johnny Hodges, a most droll guy who played the sweetest music. Jeep was very quiet, wasn't overly effusive, but he could be quietly sarcastic. I enjoyed his company.

Paul Gonsalves, who was even quieter, had a problem with being on time. Sometimes—including this trip—Paul didn't even make the bus. His seat was empty.

We arrived at the Westbury Music Hall, and everyone set up. The crowd began filing in, and still no Paul. As the Ellington orchestra began its first number, I could see Paul walking down the aisle from the back of the theater carrying his saxophone case.

As soon as the song hit a break, Paul was supposed to play a solo. I could see him up on the stage, frantically putting together his saxophone. Only seconds before it was his turn to play. The band stopped, and Paul was sensational.

After the concert I said to Hodges, "Man, I guess that's going to teach Paul a lesson." Jeep said, "Oh no, that's not going to teach him anything. Paul does that all the time." I thought to myself, *How nerve wracking!*

Duke Ellington was a gentle person who had a very hard time firing people. At one point Charles Mingus was playing bass in the band, and Charles was so disruptive that Duke no longer could abide his behavior. Duke said to Mingus, "Charles, I believe it's time for you to find other employment."

Duke was always very gentlemanly. You could see and feel this when he was on the stage. He was a very serious musician. He never really got his due as a pianist, but I loved his playing. I thought it was very delicate and sensitive.

Of course, the end of the Ellington story came when he died in 1974. I was living in upstate New York, and I opened the *New York Times* one morning, and I saw there was going to be a funeral for Ellington at the Cathedral of St. John the Divine on May 27. I told my wife, "I'm going to New York City."

I grabbed an overnight train from Westport, New York, and I arrived in New York City at eight in the morning. The funeral was scheduled for the late afternoon, but I wanted to make sure I had a seat close to the front. I went right to the church, and I was one of the first people there. By the time of the funeral, there were three thousand people inside the church and seven thousand more outside.

Every significant jazz musician who was in town that day was there. Count Basie came walking down the aisle crying like a baby. Duke and Count, who were contemporaries, had a wonderful relationship. Ella Fitzgerald came (and sang), as did Sammy Cahn, the composer, and Stanley Dance, Duke's biographer. I remember seeing Hodges and the rest of the orchestra.

We were all teary. It was an afternoon of tears. Father O'Connor gave the eulogy. Throughout the ceremony, everyone cried.

Even after Duke's death, his orchestra was able to go on, led by Mercer Ellington, Duke's son. Today it's all different musicians, whites as well as blacks. Back then it was all black except when Louis Belson was the drummer,

1943–52. Louis was married to Pearl Bailey for thirty-eight years.

Nineteen sixty was a changing year in the world of jazz; it was a year where perennial favorites no longer held sway in many of the musical categories. This change was also evident in the larger political and social world of black Americans as more and more moved into elected positions of authority. We at *Metronome* did not really equate the two, rather we were only interested in the fact that Cannonball Adderley and John Coltrane replaced Paul Desmond (alto sax) and Stan Getz (tenor sax) as winners in the *Metronome* reader's poll. This was also followed by the diminished position of the Stan Kenton and Woody Herman bands. Taking over first and second places were Count Basie and Duke Ellington, respectively, followed by the Maynard Ferguson band, with the now renowned Quincy Jones orchestra coming in sixth.

I can still recall with great joy the night I photographed Quincy's orchestra at Basin Street East, with Billy Eckstine singing his heart out while the band blew behind him. The music is still available on a CD with my photographs on the cover.

The influence of African American musicians in mainstream jazz was becoming more and more apparent as evident within other categories of the 1960 jazz poll. Thelonious Monk replaced Bill Evans in the piano category; J. J. Johnson took over first place in the trombone section.

One category that remained almost all white (first seven places) was clarinet: Jimmy Guiffre, Tony Scott, Buddy DeFranco, Benny Goodman, Pete Fountain, Pee Wee Rus-

sell, and Art Pepper, before African American player Jimmy Hamilton (Duke Ellington Orchestra player) breaks into the top ten at eighth place.

But it was evident that "times, they were a changin'." The 1960 jazz poll broke it down this way: Drums: Max Roach; Guitar: Wes Montgomery; Vibists: Milt Jackson; Small Groups: The Modern Jazz Quartet; Female Vocalists: Ella Fitzgerald, followed by Anita O'Day, Nina Simone, and Sarah Vaughan. Frank Sinatra still held the number-one male vocalist position, with Lambert, Hendricks, and Ross taking over first place in Vocal Groups.

What is truly amazing is how many of the musicians mentioned in the 1960 reader's poll remained on top for years and years to come. Yes, Julian (Cannonball) Adderley took first place, but he was followed by Ornette Coleman (third place), Sonny Stitt (fourth), Johnny Hodges (fifth). Phil Woods placed tenth. Phil, a great jazz ambassador, is still making music, still blowin'. In the trumpet section right behind Miles Davis was Dizzy Gillespie, Art Farmer, Lee Morgan, and Maynard Ferguson breaking into the top five. The changeover was coming. We did not actually dwell on color as much as comment on the type of music being listened to by the jazz audience, and there was no doubt that the listening audience was getting younger and younger, more in tune with what was happening at the time rather than on what had been going on before. This change took place gradually, and continues today within the American culture and psyche; witness the fact that someone who calls himself an African American became the first to reach the highest office in America. Yes, there were others—Jesse Jackson, Shirley Chisholm—who were never really taken too seriously.

But President Barack Obama is the real deal.

5 The Demise of *Metronome*

The one glitch in the running of *Metronome* was that our editor, Bill Coss, was unreliable and drove Bob Asen, the publisher, to distraction until Asen finally let him go. In December 1960 Asen hired as managing editor David Solomon, who was in the promotion department at *Esquire* magazine. Asen was hoping that Solomon would bring a hip *Esquire*-like sensibility to the magazine—more politics, culture, up-to-date issues.

Solomon was hip all right. Solomon and Asen got into it almost immediately. Nevertheless, I had to give Dave credit: ideas spilled out of him. One time he told me to call President-elect John Kennedy, who was then at his family home in Florida—prior to his being inaugurated as the thirty-fifth president of the United States. I thought he was out of his mind, and I told him so. He said, "There are no black performers and no jazz performers at Kennedy's inaugural, and we should call Kennedy and tell him to do something about that."

I still thought he was asking for the moon. I said, "Just pick up the phone and call the president-elect of the United States, and when he answers, I'll just introduce myself and ask him to include Dizzy Gillespie at the inaugural ball. Just like that?"

Dave said, "Yep, just like that, Herb. Do it."

I went to my desk and called the information operator in Palm Beach. I asked for the telephone number for President-elect John Kennedy. She gave it to me.

I dialed, the phone rang, and a man answered. I said, "This is Herb Snitzer from *Metronome* magazine. I'd like to talk with President-elect Kennedy."

"He isn't available right now," was the reply. "I'm Pierre Salinger, his press secretary. May I help you?" Trying to stay composed, I told Salinger that Kennedy ought to invite Dizzy Gillespie to the inaugural ball. He said that Frank Sinatra was handling those details, and I should talk to him about it. He gave me his number in California, thanked me for calling, and hung up.

I dialed Sinatra's number, and his manager answered. I told him the same thing I told Salinger, that Dizzy Gillespie should appear at the inaugural. He said he'd deliver my message to Frank, and we hung up.

To start the new year right, *Metronome* came out swinging even before the bells started ringing. On December 27, 1960, we dispatched a telegram to President-elect John F. Kennedy, which read:

PRESIDENT ELECT JOHN F. KENNEDY,
PALM BEACH FLORIDA
DEAR MR. KENNEDY.
THE STAFF OF METRONOME MAGAZINE, AMERICA'S
LEADING JAZZ PUBLICATION HAS ENTHUSIASTICALLY
READ IN THE NEW YORK TIMES . . . OF THE MUSICAL
PROGRAM YOU HAVE PLANNED FOR YOUR INAUGURA-
TION.
METRONOME GREETS WITH APPROVAL OF A YOUNG
AMERICAN CLASSICAL COMPOSER TO PERFORM AT
YOUR INAUGURATION. WE FEEL HOWEVER YOU HAVE
OVERLOOKED THE ONLY ORIGINAL ART FORM DEVEL-
OPED BY AMERICAN CULTURE. . . .

The telegram goes on for quite a number of columns, ending with the following:

METRONOME MAGAZINE IS PROUD TO OFFER AS GUEST
PERFORMER, AT YOUR INAUGURATION, THE WORLD'S
GREATEST JAZZ ARTIST, JOHN (DIZZY) GILLESPIE, AND
HIS FIVE PIECE GROUP. PLEASE ADVISE AT ONCE IF THIS
MEETS WITH YOUR APPROVAL.
CORDIALLY,
ROBERT ASEN, PUBLISHER
DAVID SOLOMON, EDITOR

The *Metronome* article announced:

Mr. Kennedy, through the offices of his swinging impresario, Frank Sinatra, declined the offer . . . 'there wasn't enough time to squeeze' John Birks in. We sympathize, because we know that it has never been easy to squeeze Diz in.

We heard back that Sinatra was very angry with us for sending the telegram to the president-elect, but no more so than we were angry at Sinatra for forgetting his roots. Fortunately, we were three thousand miles away from Sinatra and safe from his verbal and sometimes physical responses.

Meanwhile, under Solomon's leadership, we were publishing a magazine every month that featured something truly revolutionary: our focus was on the young black jazz performers who were transforming music in America—the new young turks of the era, the whole bebop generation—basically black artists.

Up to then, the magazine mainly wrote about the big-band performers, Count Basie, Duke Ellington, seldom focusing on the new personalities, and all of a sudden we were focusing on young artists like trumpeters Lee Mor-

gan and Booker Little, and this young black kid from Texas known as Ornette Coleman with his plastic white saxophone. We proselytized, telling our readers how creative these individual black performers were.

In addition we also published the work of American photographers, because we as a staff took the view that we were publishing a cultural magazine, not a music magazine per se, and photography was an American art form. With my interest and love of photography and photographers and my interest in history, we brought into the magazine stories about these and other photographers: Mathew Brady, Alfred Stieglitz, Roy De Carava, Berenice Abbott, Aaron Siskind.

Dave also wanted to bring top American writers into the mix, and for the March 1961 issue we ran articles by Le-Roi Jones, Henry Miller, and Lenny Bruce, and in the April issue, a group poem—"Pull My Daisy"—by Allen Ginsberg, Jack Kerouac, and Neal Cassady.

In that same issue we covered a historic evening that featured a duet with Dizzy Gillespie and Ornette Coleman at the Jazz Gallery downtown on St. Marks Place. Any time Ornette played was a big deal in the jazz world. People didn't quite catch on to his music any more than they did Cecil Taylor. It was all part of jazz to come, free jazz. When Dizzy and Ornette were scheduled to jam, everyone, including Dizzy, wondered what would happen.

The duet came about because of the editors of Metronome. When Dave Solomon went to interview Dizzy for an article, he brought with him an Ornette Coleman album entitled *Change of the Century*. Dizzy listened to the album, said little, but when Dave asked him if he would be interested in playing with Ornette, Dizzy said he would.

Ornette idolized Dizzy. It had been Ornette's dream to play with him. When Ornette and Dizzy both showed up, they embraced. Associate editor Dan Morgenstern later wrote:

And so, there they were. For the younger man, who had come to New York with an LP on the market and consierable publicity, and from then on had made it on his own, it was a portentous moment. Ornette had played alongside his peers on many occasions, at Newport, for example. But this was a gesture of acceptance and warmth, the likes of which had so far been withheld. For Dizzy this was an act in the spirit of the jazz tradition which had given birth to himself. And for both men it was a challenge to do their best. But solemnity is not a Gillespian trait. "We are now," Dizzy announced, "going to play five different tunes, all at the same time." . . . the five different tunes turned out to be one, Bernie's by name. It began in unison, the group finding its way into firm time by the end of the statement. Ornette soloed first and it soon became apparent that he was not about to modify his approach for the occasion. What came out was Ornette Coleman; the harsh, sometimes fierce sound that is so definitely a jazz sound, the long explosive runs which never sound mechanical and seem to stem from the throat than the fingers; all of it imbued with that urgency which is basic to Ornette Coleman's playing.

Dizzy watched Ornette (who, eyes closed, neck bulging like a trumpeter's, horn held firmly aloft, is well worth watching) . . . When Ornette had spoken his piece, Dizzy came in, restating the theme in subtle paraphrase for momentary reorientation. And Dizzy explored, probed,

and finally soared, swinging ferociously all the while.

. . . Dizzy was seasoned, beautifully structured and full of controlled power.

They went out together.

Both maintained the integrity of their individual styles. Both cast their spells.

For our next issue, April 1961, I went to photograph Jazz Day at Macy's. Jazz musicians needed as many gigs as they could get, and when the PR guy from Macy's decided it would be a great kick to bring in a whole bunch of jazz musicians, when Macy's offered a decent payday as a sales come-on for the store, a number of top musicians jumped at the chance.

By 1961 rock 'n' roll was putting jazz musicians out of business. The Beatles would finish many of them off a couple years later. Except for the big-band stars like Benny Goodman, Cab Calloway, or Duke Ellington, musicians, especially the sidemen, the everyday guys, were having a hard time making a living. Back then they didn't have the Jazz Foundation, which today is trying to help out the older musicians who don't have anything (helping with health care and hospital bills). All they wanted to do was play their music. Why shouldn't they have had the right to do that? Why shouldn't the country have said, *We value your art, and we'll take care of you?* But it doesn't work that way in this country.

That afternoon at Macy's one of the featured performers was Jimmy Rushing, the singer of the Count Basie Orchestra before Joe Williams. Jimmy was "Mister Five by Five." He was short and fat, and boy, could he sing.

One time I was at a jazz festival in Virginia Beach. I was in the dressing room, sitting in the back when Rushing came in. He was up in age and he wasn't feeling well. And there were some other white people in the room.

I said to him, "Jimmy, sit down. Take a load off your feet. You don't look too well."

He said, "Herb, I don't sit when white people are present."

I thought he was putting me on. He wasn't. After all, when the group of Lambert, Hendricks, and Ross played in the South, they had to stay in separate hotels because Hendricks was black. So Jimmy would not sit down.

Jimmy sang at Macy's. J. J. Johnson, Dizzy Gillespie, Buddy Rich, Stan Getz, Lionel Hampton, and Gerry Mulligan played. An all-star crew. Jackie Gleason, the star of *The Honeymooners* television show, played the "12th Street Rag" on the banjo. Later in the afternoon Benny Goodman finally showed up late, and when he finally arrived and gave the downbeat to "Avalon" with Teddy Wilson on piano, Gene Krupa on drums, and Lionel Hampton on vibes, the place went wild, with the Macy executives a bit nervous but the music won them over as well and the set was alive. Benny and company played it as if it were 1937.

Dan Morgenstern wrote, "After refreshments for the musicians and assorted free-loaders things got underway with Hamp, Gene, bassist Milt Hinton, pianist Horace Silver and Stan Getz." Stan was emotionally mercurial, at times charmingly open, other times very mean spirited. Zoot Sims once remarked that Stan was a "nice bunch of guys." His personality was determined by what his body was either needing or fighting off.

I saw Stan at Lewisohn Stadium, the crowd in a festive mood. He was on the same bill as Louis Armstrong, who went on first. It was classic Pops. Stan played beautifully in the spirit of Lester Young, and backstage, lending their

support, were Armstrong's manager, Joe Glaser, saxophonist Gerry Mulligan, trumpeter Dizzy Gillespie, and many others.

It was an afternoon of fun at Macy's, and we had a two-page spread in the April 1961 edition of *Metronome*.

By this time I knew quite a few of these musicians. I had known Dizzy Gillespie for thirty years. Dizzy Gillespie was anything but. He was a lot of fun, but he wasn't dizzy. I always called him J. B., which stood for John Birks Gillespie, his full name, because I couldn't call a grown man "Dizzy," especially when he wasn't—except when he was performing.

Let me tell you a story I heard about Dizzy. Dizzy was with the Cab Calloway band. They had finished a gig, and they were driving through the night, and they came upon a hotel. Dizzy went inside, and he was wearing a Moroccan fez, that red hat. The guy behind the desk says, "Can I help you?" Dizzy says, "My friends and I need rooms." The guy says, "We don't rent to niggers." Dizzy got all upset, and he said, "What are you talking about? I'm from Morocco. I'm African." The guy had to be stupid or drunk, and he said, "Oh, okay, that's different." He gave them all rooms for the night.

Dizzy went back out to the bus, and he said, "Okay, I have us all rooms. Don't say anything. Just come in and go to your rooms."

Dizzy told the guy, "I'm not an African American. I'm African, from Morocco." And that was okay. To me that was the height of imbecility.

Lionel Hampton was another musician I saw a lot of. He gained his fame playing vibes, but he had started out as a drummer, a very good drummer. Lionel seemed like one of the most far-out musicians, as if he was not of this world but from somewhere else. You could have a conversation with him, but even while he was talking, you'd think, *His head is somewhere else. He's on a different plateau,* which was interesting because he was a rock-ribbed Republican. This guy was so into being a Republican, he made no bones about it.

I also got to know Benny Goodman. He used one of my photos of him on an album cover. When I met him, it was at his spacious penthouse apartment on the East Side of New York. He was making two thousand dollars a week when the average salary was forty dollars a week.

Benny was a businessman, and in the photo I made of him, he was in a suit with a white shirt and a tie, puffing on a pipe—very staid.

From what I understand from other musicians, Benny could be very nasty, just not a nice guy, and I figure that must have come from being so successful at such a young age. After all, early celebrity did in Stan Getz for a long time. Stan was eighteen years old, playing in the Woody Herman Orchestra, and he spent the next twenty years as a heroin addict, stealing, and landing in jail. If you "hit" very young, sometimes it's difficult to see yourself in perspective. You're really not as important as you think you are, Benny. You know? You didn't save the world. But in his own mind he did. He was famous, and he owned a radio program during the forties. When you think of swing you think of Benny Goodman and Fletcher Henderson. As a matter of fact, when the Fletcher Henderson Orchestra folded, Benny hired Henderson to do the arrangements for his orchestra, and when that happened, the Benny Goodman Orchestra soared. Fletcher was black, but at that time the country could only take just so many black orchestras.

Beginning with the July 1960 issue, *Metronome* featured a series of concerts that took place in the outdoor garden at the Museum of Modern Art (MOMA). Editor Bill Coss and I came up with the idea. We wondered, *How can we get jazz into the museum?* We saw the relationship between modern jazz and modern painting. MOMA's director lived next door to Bob Asen, our publisher. Bob made the introduction, and Bill and I met with the director and told him what we wanted to do. He thought it was a great idea.

The first group to play was George Wein and his All Stars. George was the founder/producer of the Newport Jazz Festival. George is also a pianist. He had an interracial marriage fifty years ago. He presently lives in New York. The Playboy Jazz Festival and so many others are the product of George Wein's vision.

I can remember him starting off the concert, he nodded toward a sculpture of a full-bodied woman by Gaston La Chaise, and he said, "We're going to start the concert with a tune that reflects the sculpture. It's called 'That's a plenty.'" And they started to play. It was great. That entire summer, every week, a different group played at the Museum of Modern Art, including Coleman Hawkins, Roy Eldridge, Art Farmer and his group, Jimmy Giuffre and his group. It went on for ten weeks like that.

Every week the garden was filled with people, and we set up a table in order to sell subscriptions to the magazine. We gave away free copies. The series brought us a lot of publicity, but it didn't do much for our sales. Every week Whitney Balliat in the *New Yorker* wrote about our concerts. We couldn't have gotten any better press. The *New Yorker* really legitimized what we were doing. But even at thirty-five cents a copy, we were hurting for subscriptions.

The MOMA concerts continued for two summers; 1961 saw the likes of Bud Freeman's All-Stars, Slide Hampton,

trombonists Al Grey and Billy Mitchel, trumpeters Buck Clayton and Ted Curson, pianist Randy Weston, the Stars of Faith Gospel Choir—a virtual all-star group of jazz artists performed through the 1961 summer.

Desperation makes you do desperate things. In another attempt to bring the magazine to the attention of the public, in the July 1961 issue Dave Solomon wrote an article about a stripper. A freelance photographer by the name of Mario Jorrin had taken very provocative photographs of her, and Dave bought them and put one on the cover. Other shots of her were published inside the magazine. Dave really thought that publishing these photos would be terrific. None of us agreed with him, but he was the boss and he ran them. What this stripper had to do with jazz none of us could figure out. A few of us were offended, but if Solomon's aim was for her to draw attention to us, he certainly succeeded. This was 1961, the end of the conservative Eisenhower years, and the result was that several countries and many libraries banned the issue, calling it pornographic. People wrote in saying, "What are you doing? It's stupid. Who's idea was this?" And it was my understanding that Spain and Mexico and a couple of other Catholic countries refused to distribute the magazine. In today's world, it's nothing, but back then, fifty years ago, people got upset when they saw a little flesh. Again, it heightened our profile, but this didn't result in subscription sales. In 1961 we were up against rock 'n' roll and the folk scene, and *Downbeat* magazine, which didn't have to worry about subscriptions because its owner wanted to lose money. He was making so much money in his other ventures that he used *Downbeat* as a loss leader, as a write-off. As for *Metronome,* we were up against it.

Bob Asen was furious. Dave Solomon was hardheaded, and he wanted what he wanted, until Asen couldn't take

it any longer. Asen, tired of Solomon's dictatorial ways, put his foot down and cut him loose. He named Dan Morgenstern to replace him. Rather than bring in someone else, Bob asked me to take on the added job of associate editor. Dan and I became the last two editors of *Metronome* magazine, commencing with the October 1961 issue.

For the August 1961 issue, I went to the Virginia Beach Jazz Festival, where I made a photo of Buddy Tate, a great saxophone player and a very nice man. You would never know Buddy was a jazz musician. He could have been an accountant—until he put that saxophone to his mouth. He drove down to the Virginia Beach Jazz Festival from New York with trumpet player Buck Clayton. He described the trip to me. He said, "It's twelve hours from New York to Virginia Beach. We stopped, went to the bathroom, got something to eat, gassed up our car, all in one place, and we came here. We're going to spend thirty minutes performing, another thirty minutes joking with friends, and then we're going to get back in our car and head back to the old Mason-Dixon line. I don't want to spend any more time in the South than I have to."

That happened a lot. When Charlie Parker first went down South, he had in his band a trumpet player by the name of Red Rodney. Red was a red-haired young Jewish guy from Brooklyn, but he looked like a *high yella,* what white bigots called any light-skinned black. So Charlie and Red were able to travel and stay together because the whites thought Red was black. Isn't that stupid?

In August 1961 Dan said to me, "Why don't we do a picture of as many jazz trumpet players as possible." It was to be the kickoff for a series, with a shot of all the saxophone players to follow, and a shot of all the drummers next, and so on. We chose to do the trumpet players first because

we figured if we could get Louis Armstrong, Roy Eldridge, Buck Clayton, Miles Davis, and all the others all in one picture, it would be sensational.

We invited thirty musicians. Dan and I called them up one at a time. If we didn't have their phone number in the Local 802 union book, we found them in the phone book. I started calling. I knew most of them, and I invited them to show up at the Harlem boathouse in Central Park. I said, "If you want to bring your trumpet, fine." Most of them didn't.

Some, including Louis Armstrong, who dearly wanted to be in the photograph, were out of town that day and couldn't make it. Art Farmer, a great trumpet player, wasn't available. We tried moving the date to accommodate Pops and Art and several others, but when we did that half the other guys couldn't come.

When I called Miles Davis and asked him to come, true to form Miles said he wasn't coming. Okay, Miles. But he was the exception. When the word got out as to what we were doing, it created a buzz, and on a hot August 1961 afternoon twenty-two jazz trumpet players arrived at the Harlem boathouse for the picture. The shoot and story appeared in the November 1961 issue entitled "The Trumpet in Jazz." It should have been "Pops Couldn't, and Miles Wouldn't."

I said to Dan, "How are we going to arrange them?"

Dan was very cool about it. He said, "Let them seat themselves."

We decided to shoot the picture in an area where there were picnic tables.

I said, "Okay guys, we're ready. Why don't you take a seat here?"

I was shooting with a 35mm camera with no strobe light. I shot twenty-two mostly blacks guys against the bright sky.

If you look at the picture, you'll see that the front line included Charlie Shavers, Dizzy Gillespie, Roy Eldridge, and Buck Clayton, four of the great trumpet players of their day.

The other musicians positioned themselves, and I found it interesting that the white players drifted to the back, while the black players moved to the front. Among the trumpet players in the picture were Red Allen, Booker Little, Freddie Hubbard, Yank Lawson, Ted Curson, and so many others. Way in the very back of the picture is this white musician, a very young Doc Severinsen, who for years was the leader of Johnny Carson's *Tonight Show* band.

That was a wonderful day. It was incredible to get all these guys together and to see them react to one another, joking and carrying on. They were such a grand group. I just love jazz musicians. But that was the end of the road for *Metronome* magazine. A month later, in September 1961, Bob Asen told the staff that he was pulling the plug on the magazine. The last issue was December 1961, featuring on the cover saxophonists Coleman Hawkins and John Coltrane; Hawkins featured on our June 1960 cover and once again on our last issue. Bittersweet.

6 Europe and Cambridge

With *Metronome* going out of business—for the last time—I decided to go to Europe for three weeks, hoping to find some calm and new experiences both in and out of the jazz world. I knew up front that I was going to visit the Summerhill School in Leiston, Suffolk, England as I had

read a book by its headmaster, A. S. Neill, and was taken by his way of educating children. I also was going to see Zoot Sims, the great Woody Herman tenor saxophonist as he was playing at Ronnie Scott's club. I planned to meet up in Paris with French photographer Lucien Clerque, whom I had recently befriended in New York at the request of Grace M. Mayer, the assistant to Edward Steichen at the Museum of Modern Art. (Grace, while director of photography at the Museum of The City of New York, enabled me to have my first museum exhibition. She remained a dear friend all through her life.) Well, here I was in London, and soon I was almost killed by an automobile because I looked left instead of right. I had forgotten that automobiles drove on the left rather than right side of the road. I was pulled back by people waiting to cross the street, thankfully. Not a good way to start the trip. As the days passed I photographed the street life in both London and a few surrounding areas; amazingly many of those early London images (and Paris images as well) have held up, strong and powerful in their own right.

Meeting Zoot at Scott's place was easy enough and we made arrangements to meet again in Paris at the famous Blue Note Café.

Going to Summerhill became a life-changing event as I returned there in 1962 to do a book on the school for the Macmillan Company, which eventually led to my leaving the world of photography and co-founding an alternative school based on the principles of participatory democracy and voluntary classes.

My stay in London was especially wonderful. I spent that time living at the home of Peter and Ann Piper. Peter was the director of the London Portrait Gallery, a very important museum of the art of portraiture. He and his

family were most gracious and I recall with great fondness how open and giving they were to me. I am sure they did not agree with A. S. Neill's education principles but that did not get in the way of dinner conversations covering so many issues of importance to the English, especially the way the United States threw its weight around the world (some things never change). I was growing, changing, becoming more and more in tune with life, yet at the same time having a terribly difficult time personally. A marriage was ending and my energies were focused on my art, writing, inquiring about people, events, happenings throughout the world.

I then went on to Paris, to meet with Lucien and his wife. I stayed at the Hotel de Seine, along the Rue de Seine, each night costing me one American dollar, including breakfast. It was cheap then, being an American in Europe. If it cost me a dollar a night, what must it have cost for Richard Wright, Ernest Hemingway, and all the other American writers and painters, sculptors, photographers to live in Paris during the 1920s and 1930s? I imagined one could live in Europe for a year on less than five hundred U.S. dollars. And so many did. Race played a hand in why many black artists left the United States, finding it much easier, emotionally, to live among people who didn't seem to see "color" as much as good manners and talent.

I met Lucien a number of times in my week in Paris. We spent a great deal of time just walking around, making photographs, trying to stay warm as the weather got colder (November in Paris is still a delight, as my wife and I experienced when we returned there in 2005, celebrating our wedding anniversary as well as my birthday.) Lucien was very gracious.

My meeting with Zoot at the Blue Note was surreal. He was already on stage when I arrived and I immediately saw that he was drunk. Coming off stage we greeted each other and talked through his intermission. He then went on to play another set, continuing to do this through the evening, getting more and more inebriated as the night went on. I bid Zoot goodnight, telling him that I would be back the next evening before returning to America.

I arrived early. Zoot was already there, and we greeted each other with a hug, at which point Zoot said to me, "Herb, where were you last night? I thought you were going to show up." I looked at Zoot and realized that he wasn't "putting me on," that in fact he was quite sober and his questions quite sincere. I simply and quietly told him that in fact I was there and we did talk through the evening.

He ordered a drink, scotch on the rocks. It was another great evening of music. I didn't see Zoot again for over twenty-three years, but was honored when his widow, Louise, called and asked if she could use one of my later (1983) photographs on the memorial flyer. Of course, without question. He was such a terrific guy and a wonderful musician.

I returned home, almost broke, certainly unemployed, but I enjoyed the freedom. I was determined to return to England and the Summerhill School, which did happen as one contact lead to another and lo and behold, the Macmillan Company gave me a twenty-five-hundred-dollar advance on sales. I returned to England for a stay of three months, working on and finally publishing "Summerhill, A Loving World" in 1964.

With the demise of *Metronome* magazine, the golden age of jazz came to an end for me. Between the folk sing-

ers and the Beatles, the hunger for jazz became less and less in America. I returned to the life of a freelance photographer, and for the next two years I worked for the *Saturday Evening Post, Time, Fortune, Holiday*, and *Show,* where I wrote and made photographs of popular figures, including Casey Stengel, Robert Oppenheimer, Hedda Hopper, Tennessee Williams, Bette Davis, and Sonny Rollins.

In the spring of 1964 I left New York City for the Adirondacks.

For thirteen years the Lewis Wadhams School prospered. As headmaster I watched hundreds of youngsters thrive and learn and go on to college. But the school's financial woes brought my fulltime career in education to an end, and in July of 1976 my family and I moved to Portland, Maine, where I established a jazz concert series. It was short lived.

In 1978, my family moved to Cambridge, Massachusetts, where I rekindled my love of jazz and reunited with some of the musicians who had befriended me back in New York. I also started working for Polaroid Corporation, a job I held for the next four years.

Dizzy Gillespie was playing at the Boston Globe Jazz Festival, and Fred Taylor, one of the producers, and me, went out to Logan Airport in a chauffer-driven limousine to pick him up. We were taking Dizzy around to various radio stations, because he was appearing with what was then called the Dizzy Gillespie United Nations Orchestra. I'm photographing Dizzy in the limo, and at the end of the day we end up at WGBH, the flagship of all the PBS affiliates. I said, "Oh man, I made a big mistake." Dizzy said, "What's going on?" I said, "My car is on the other side of town, and you're going to be here quite a while."

Dizzy said, "Take my limo." I said, "I can't take your limo. How are you going to get to your hotel after you're done here at GBH?"

Dizzy put his hand on his chest as if he were hurt, and he said, "Herb, I'm Dizzy Gillespie. I'll get to my hotel."

I said, "Solid," and I gave him a big hug good-bye, and I jumped into his limo. Off we went. The driver said to me, "Wow, that was some important person."

I said, "That was some very nice person."

Nina Simone was another outstanding artist whom I met early on. I met her because Colpix Records wanted me to photograph her for an album cover. She was living in Philadelphia, so I set up a photo shoot at the Philadelphia College of Art, where I had gone to school. I took her into a studio with a black background and out of that session came a number of fine images. One was used on her first Colpix album titled "The Amazing Nina Simone." But there were other photos from that shoot that I personally prefer.

Nina and I were the same age, and we hit it off. We liked each other, and we started seeing each other socially. I would go to her apartment in Philadelphia, and she would sing, and I would sit back and listen, enthralled. When Nina moved to New York, I saw her all the time. She became a part of my family, until her career took off and she became famous and my career took me in a different direction and out of the city.

In April 1986 Nina Simone came to Boston to perform. She was a part of the Boston Globe Jazz Festival. I knew she'd be staying at the Park Plaza Hotel, and I just wanted to see her again. We had been really close friends, and I was hoping we could get back to that.

I went up to her floor, knocked on her door, and she

opened it. She was wearing a bathing suit over which she wore a fur coat. I thought, *Wow, maybe I'm making a mistake,* when she said, "Herb, what are you doing here?"

I said, "I live in Cambridge now. I heard you were going to be at the festival tonight, and I wanted to come and say hello and see how you're doing."

She said, "Can you come back tonight and help me get ready to go to Symphony Hall?"

I was honored to do so. I asked her what time she wanted me to arrive, and she told me, and when I went home, I told Alice, the woman I was seeing at the time, about going to be with Nina, and she said, "She's my favorite jazz singer. Can I go with you?"

I didn't see why not, and we got to the hotel to be with Nina. Meanwhile, at Symphony Hall, Freddie Hubbard was playing, and Nina, who was the star act and who was supposed to go on after him, hadn't arrived. George Wein, the producer, called Nina on the phone in a panic. He said, "We'll give Freddie one more tune. You gotta get over here."

I could hear her cursing him on the phone.

"Fuck you, I'll get there when I want to get there," she said. I was embarrassed. Alice was horrified.

Finally, I helped Nina get downstairs, and we climbed into the limousine to take us to Symphony Hall. The whole time she was bad-mouthing everybody.

"You fucking people don't know what you're doing. I don't need this." It was almost as if she was crazy. Life had made her so bitter and angry. She had had guys who had screwed her over, and she had managers who stole her money. It was just terrible to see that this happened to her.

When we arrived Freddie Hubbard's group had come off the stage, and with some prompting from George Wein, Nina finally left her dressing room and headed onto the stage.

Symphony Hall holds about forty-five hundred people. Sitting on the stage was her longtime guitar player Al Shackman, and when she walked out and the spotlight hit her, the entire audience got up and cheered and cheered. She bowed low to acknowledge the applause, and I said to Alice, "This is what she's all about." But it was all downhill from there. During her performance she even cursed the audience. When she came off stage she was muttering under her breath, "I'm never going back on that fucking stage. People don't appreciate what I do." George Wein said to me, which he has since denied, "I'll never book her again."

The night ended, and we went back to the hotel. I made a good photograph of a more relaxed Nina and Freddie Hubbard together. Alice and I said our good-byes, and while we were driving back to Cambridge, Alice said to me, "If the jazz world is like what I experienced tonight, count me out." That's how traumatized she was.

Eight months later, in early December 1986, I was in my studio when the phone rang. It was Nina. She asked, "Would you go to Switzerland with me and photograph a week of concerts I'm going to do? I can't pay you, but I can cover all your expenses." Right before Christmas a freelance photographer isn't doing very much, so I said okay.

I flew from Boston to New York and met her at the Pan Am terminal. We got on a plane to go to Bern, Switzerland, the capitol where she was performing. We stayed at a five star hotel where my bathroom was bigger than my Cambridge living room.

I had never been to Switzerland, but after two days with Nina I wanted to go home. Being with Nina was terrible. She would walk into a restaurant and see a table with a "reserved" sign on it, and she'd sit down even though it wasn't reserved for her. And she wouldn't budge. She'd then holler at the maître d'.

During the second evening I was so embarrassed by her behavior that I excused myself and went into the club in the hotel to see who was performing. Blues singer Margie Evans was on stage, and I was sure I knew her drummer behind her. I sat down to listen to Margie sing, and after the song she introduced the members of her band. She said, "On the drums, my good friend Oliver Jackson." He had been a good friend of mine during my *Metronome* days.

After the concert was over, Oliver walked back to where I was sitting, and I stood up right in front of him to stop him from getting by. He looked at me quizzically, and I said, "I'm Herb Snitzer," and he said, "Oh, my God," and he picked me up off the ground and gave me a bear hug.

We spent the next twenty minutes catching up. He couldn't believe I was there in Switzerland with him. He said, "You're not with the Nina Simone group, are you?" I said, "Yeah, she brought me over." He said, "Oh, I'm so sorry. She's got to be terrible."

I said, "It's no fun, O. J." I had another three days to photograph her, and I did the job, but otherwise I stayed as far away from her as I could. I just couldn't wait to get back home. A long time ago she had been a friend, but she had turned just awful.

When I came home from Switzerland I was determined never to contact her again, but when I had my one-man exhibition in Boston in 1990, my mural of Nina Simone was the biggest image of the show. Nina is central to the development and evolution of American music, and I was determined to tell her through my actions that friendship runs deep and loyalty is important.

When the same exhibit of my jazz photographs appeared in a gallery in Los Angeles, I left out my image of Nina and purposely didn't invite her, knowing she was living in Los Angeles at the time. I was just not prepared to deal with her antics that might disrupt the evening festivities.

The night before I was on a jazz radio station in L.A., and I was talking about the people in the show whom I knew, and the host asked me, "Do you have any Nina Simone stories?"

I said, "I'm not getting into that. Nina Simone is a great artist, a great singer whose personal life has been filled with terrible events. She's the female James Baldwin as far as I'm concerned. I love that lady, and I'm not saying anything bad about her."

Then he asked, "What do you want people to take away after they've seen your work."

I said, "A sense that African Americans have centrally contributed to the cultural and spiritual life of the United States." I waited for his response. He said nothing. I continued, "Jazz is more than wonderful music. It's a statement about a people's desire and thirst for freedom, and with freedom the sweetness of individuality and sense of self-worth." Again the interviewer kept quiet. I plunged on. "It is my thesis that jazz musicians, and especially black jazz musicians have made an important, very important contribution to the United States. Once we look at jazz this way, we must salute Pops, Duke, Sarah, Miles, and others as major American artists, not jazz artists—which they are—

but American artists. Look, Duke Ellington is the greatest American composer of the twentieth century, but you would never know it from the white press.

"Well, Duke *was* the best, just as Martin Luther King was the best. Just as W. E. B. Du Bois was the best, just as Sarah Vaughan's voice was the best." I was expressing the injustice of it all.

Nina, who was living in an apartment in Los Angeles at the time, was listening to the radio show.

A couple days later she came to my exhibition. The gallery owner knew who she was immediately. She didn't say anything. She came in and quietly went through the show. When the gallery owner introduced himself, she told him, "I heard about this exhibition on the radio."

I never saw Nina again. It was so sad. She was such a major and distinct talent. You couldn't mistake her voice for anyone else's. The songs she sang were all Nina Simone. I miss her still. She died April 21, 2003.

The march of time had had an opposite effect on Stan Getz, who had indulged too much in drugs and booze during his early years of traveling. He had been the most lyrical of tenor saxophone players following in the tradition of Lester Young. A star at age nineteen, he quickly became dependent on booze and drugs, and he would fight this battle for the rest of his life. Ironically, it was his cigarette habit that finally killed him.

Stan was mercurial, at times charming and open, and other times very mean spirited, although he was never as bad as Chet Baker. Stan's personality was always determined by what his body was either needing or fighting off.

I had photographed him during the concert at Macy's Department Store in 1961, and then not long after that I saw him play at Lewisohn Stadium. I didn't see Stan again for almost thirty years, when he came to play at the New England Conservatory of Music in February 1989.

In anticipation of this meeting I wrote Stan, reintroduced myself, and told him I would be following him around all day on assignment from the jazz department of the Conservatory. I told him I would be respectful of his time and space.

Still youthful at age sixty, Stan was suffering from lung cancer, but there was none of the darkness that had hung over him. We chatted for a long time, and he introduced me to his fiancée. I then went about my business of making pictures while he learned the score of the extended piece of music he was playing that evening. He was all business. He never lashed out at anyone, and he was patient with the student orchestra. To my eyes he was a changed man.

I sent Stan a photograph of him and his fiancée, their heads together. It was a common pose, but I thought he'd enjoy having it. A few weeks later my phone rang, and it was Stan telling me how wonderful the picture was and how thoughtful of me to send it. I couldn't believe my ears, because most jazz musicians took such gestures for granted. For Stan to call was almost unnerving. When I read in his *Philadelphia Inquirer* obituary that Stan was quoted as saying, "I finally became what I should have been all along: a gentleman," I had to nod my head. That was precisely what he had become.

He returned to Cambridge about six months later and performed in a hotel ballroom to an overflow audience. He didn't look well at all, but he was, backstage, gracious, calm, with a light in his eyes not often seen. He was sick,

everyone knew he was fighting cancer, and who knew how long he would live? The concert was typical (if Stan was ever typical) Getz, soaring lines, melodies beautifully played. The other musicians—Kenny Barron on piano, Rufus Reid on bass, and Louis Hayes on drums—were a singular heart beating with Stan. I stayed through the evening, making some more images of Stan both backstage and on stage. I bid Stan goodnight and good-bye, wondering whether we would ever meet again. We never did.

7 Conversations

Living in Cambridge gave me the opportunity to meet some of the younger jazz players for the first time. For instance, in June 1991 I arranged to interview trombonist Clifton Anderson, who was part of Sonny Rollins's band. We met in New York City in the courtyard of Lincoln Center. Looming behind us was a massive Henry Moore sculpture. By 1991 jazz had become so marginalized that CD sales of jazz records made up only 1 percent of all music sales. This was the milieu in which jazz musicians had to survive, and it wasn't easy. I began by asking Clifton Anderson why he became a jazz performer.

"I guess you know I'm Sonny Rollins's nephew. He gave me my first trombone when I was seven years old. It was after I went to see the movie *The Music Man* with Dick Van Dyke. There was a scene in the movie where seventy-six trombones led the big parade, and I fell in love with the trombone, so my mother told Sonny, and Sonny bought me a trombone. It wasn't until junior high school that I began to take the trombone seriously. I didn't recognize

what a giant Sonny is until I went to music and art school, and that's when I started playing jazz.

"When I was fourteen I went backstage at one of Sonny's concerts, and I was able to see how enamored people were of Sonny, and I could see the glitzy lifestyle, and it was then I decided this was something I wanted for myself. I also saw how the music made people feel. I recognized that everyone was so happy around Sonny.

"I was personally moved by the civil rights movement—touched, moved, influenced by that period—and I know that is a part of me and the experience is all a part of my music. Malcolm X and Martin Luther King and many other black leaders are a part of what influences me when I think about my music and the emotions or feelings I have about the society on a greater spiritual sense.

"Some people think the vitality of jazz is going to be lost, but that is a misconception. Jazz is, for the most part, chamber music. You can enjoy it at a concert level. All great music has a connection to one's spirituality. Music is universal; jazz is accepted all over the world, less so in the United States, so maybe there is another factor blocking that acceptance and recognition and support of the arts that doesn't exist in other countries. I think jazz and lots of other things suffer because most people don't see it as classical American music. They see it as something black Americans play.

"I think a lot of us have suffered from a lack of self-esteem. And so when we perform, we do so because we love what we are doing but at the same time we don't project ourselves, we don't see the actual level of respect that we should be given and should be appreciated for what we do.

"The jazz scene is a lot harder for musicians today than

it was for artists like Sonny and Monk and Bud Powell and J. J. Johnson. Back then you had much more access to jam sessions. A young musician has to go to a club to hear someone play, possibly paying up to twenty-five dollars to get into the club. There are no jam sessions or the degree of open playing there once was even when I was coming up, and I came up at the tail end of the time jam sessions were going on. Right now I think there is so much commercialism involved in record companies accepting you. I know great, great artists who make records on obscure European record labels, and many people don't know these records have even been released. And if you sign with the larger record companies, they have stipulations who they want you to use, the kind of music they want you to play, and when you may perform. I don't want to go to a record company and be restricted to what they want me to perform. I'm the artist. So a lot of the great music is being performed on small labels, and the general public doesn't get to hear this, and a lot of the artists are almost unknown. [YouTube, The InterNet, and Google have changed all this.]

"Right now the accessibility of the music and the artists to the public is very poor, particularly in the United States. You have to really go looking for it, and unless you have an idea of what you're looking for, you can get caught up in the misleading approach to jazz marketing. I think one of the best ways to be introduced to this music is to see and hear a master like Sonny. I've heard people come backstage after one of our performances and say, 'I've never been to a jazz concert before, and I never thought I'd like it, but now I'm hooked.' So I think the music is more powerful than any set of obstacles. Jazz will have its day. I'm convinced of it."

• • •

That same year I met with jazz singer Sheila Jordan while she was appearing at the University of Massachusetts in Amherst, Massachusetts. Poor as dirt, Sheila discovered that being poor and white wasn't much different from being poor and black. As a young girl Sheila moved from the desolation of coal country in western Pennsylvania to Detroit, where she found a home in the black community. But because she was white, white police officers constantly harassed her for engaging with blacks. To get away from the hassle, she moved to New York City, where she married the great bebop pianist Duke Jordan and became a staple of that city's jazz scene.

"Coming out of the poverty-stricken background I came from, I wasn't content to sing `country,'" said Jordan. "I just said, *This isn't the music I want to sing.* I was really looking for a special kind of music, to take from it spiritually so I could find what I felt. I came out of an area near Johnstown, Pennsylvania, coal-mining country. I was raised by my grandmother. We were so poor we didn't have electricity, so we didn't have lights, didn't have record players. I lived a mile from Charles Bronson. His family were miners too. I find that in any race of people, when you are poor, really impoverished, music heals, whether you are black or white. At least it did for me.

"I knew I was a singer. I found my music in Detroit when I went to visit my mother. When I was a teenager, I finally moved to Detroit to be with my mother, and that was where I heard Charlie Parker for the first time. Music was the most important thing to me because it kept me alive.

"As a little kid I was really a mess. There were times when I said, *God, if you have to live like this for the rest of your life, who wants to live?* I knew I wanted to sing, but I

didn't know *how* I wanted to sing until I heard Bird. I felt the freedom and the creativity, and I knew I wanted to feel those things myself. Here was the freedom to take a song and do whatever I wanted with it because I felt it. When I heard jazz, that made me realize I had something to live for. It all tied in. After I moved to Detroit, I started hanging out with black kids. I identified with black kids; maybe it was because of the poverty and feeling rejected. I came from a very alcoholic family, but that's another story. But I really felt close to black kids. And I wanted to be black.

"I felt comfortable with black people, comfortable with the music. I got a lot of warmth and love and understanding from black people. And the people I grew up with are the great players of today: Tommy Flanagan, Barry Harris, Kenny Burrell. Top guys. I remember being called down to the office of my principal, and she said to me, 'You are such a nice gal. Why do you hang around with colored girls?' I lied. I said, 'I'm part colored.' I told this to all the white people who gave me a hard time.

"So I found my family among the black community of Detroit. I just totally identified with black people. There is still a part of me that is very sorry I wasn't black. But that is also why I never tried to copy any of the great black singers, like Billie or Sarah or Ella. As a white singer I didn't want to steal anything from a black singer because I felt they were robbed enough.

"As a young girl I wanted to go where the music was happening in Detroit. There wasn't a big white jazz following in Detroit. Most of the people were black. I tried getting into a jazz club called the Club Sudan. Of course I wanted to sing, but I was scared to death. The cops were constantly stopping me because I was young and white

and I had black friends. I took a lot of chances. I tried everything to get in, including putting on dark pancake makeup to look older and black. It was so bizarre. I never drank in the clubs, so I never got busted. But it was a constant battle, degrading, sometimes being taken down to the police station and searched. We were told, 'You don't hang out with them, understand?' It was then I knew I had to get out of Detroit and move to New York. I wanted to be near Charlie Parker's music.

"I went to New York to study under [pianist] Lenny Tristano. A lot of musicians would come to his loft. This was the mid-fifties. Even in New York if I went out with a black woman, we would get the stares and the hard looks from people. It was a drag, almost all the time, except within the jazz world.

"But feeling the pain and the rejection of the black people by the whites made me more honest. Hell, I didn't want to sing white music. If anything I was going to be more dedicated to jazz because of the race thing. I'm never uneasy about singing this music because I've got my own sound. One of the joys I really get is from a black musician or black singer who really digs what I do. It's like being adopted. Somebody adopts you, and maybe they aren't your real parents, but they love you, dearly, and that's how I feel. I've been adopted into this music, and I've earned my place in it. I try very hard not to let comments about it not being my culture, or I have no right to do it, bother me."

Abbey Lincoln was another jazz singer I was crazy about. An introspective artist; a chanteuse who seems to sing with a tinge of sadness, she had been married to legend-

ary drummer Max Roach, and she had sung on his recording of the Freedom Now Suite. Now in her eighties, she continues to make records.

I had met Abbey at the ping-pong tournament *Metronome* held for jazz musicians in 1960, and after I moved to Cambridge, I saw she was playing in a little nightclub there, and I looked her up. We then met at her home in Sugar Hill in Harlem. Duke Ellington had lived across the street, and Coleman Hawkins lived a block away. Abbey turned out to be a spiritual, almost a mystical, person.

She said, "I wrote a song that goes, 'I live in a world that never was my own. A world of haunted memories of other worlds unknown. I'll tell them of my trouble here when they call me home.' And I think everyone feels what I feel. You look up in the sky and wonder, 'Where did I come from? I wonder why I'm going through this.' We all live in a world of scattered thought and illogical thought with stores that are not based on anything real, that have nothing to do with the world we experience. It is difficult for people to find happiness here because we are told so many lies as children—fairy tales, stories. It creates adulterated grown-ups. In that way we all suffer the same fate: none of us gets away. It's a common life.

"I am evolving and becoming more conscious of myself, of my being. It is a development that comes from the work. Practicing the arts helps develop the senses, the abilities to comprehend. I find life to be a scientific adventure. Nothing is made through happenstance except confusion. There is a real, sincere, excellent mind-boggling planet of existence.

"It's like when I was a little girl in school. I discovered I could get to the second grade by learning everything I was supposed to in the first grade. I think life is like that. We learn what it is to live on this planet. Most times we become disillusioned, unhappy or bitter, and old and tired and feeble and weak, and die with almost nothing we were given. Everything is gone before we leave.

"I am disillusioned and *better,* not bitter. I'm glad that all they told me was a lie and not the truth.

"I sing. I write. I act out things sometimes. I practice the arts, and I'd be doing this whether anyone is watching or not. The arts come first, and the industry comes second in the real world. I know the strength of my position. I make what I want to make. If the people say you are great, you are. So it is the best work I know, and I am thankful I was introduced to it and had the chance to be involved in it.

"I've lived a number of years, and I don't feel all at sea. I sing about the life I know. A great lyric poet and songwriter by the name of Bob Russell taught me when I was young how to judge a song for its merit. He wrote a lot of great songs, including 'Crazy He Calls Me' and 'Don't Get Around Much Anymore.' He told me a great song has originality of thought and has to be succinctly said. I look for these kinds of songs that say what I want to say. All songs have a philosophy. I've never heard a song in my life that didn't have a message.

"My culture has a lot to do with the songs I sing and how I sing them. The African culture produced brilliant artists, singers, dancers, musicians, and storytellers. The holdovers of this lifestyle are the abilities African Americans express and are privileged to possess, even now. It is as natural as the texture of our hair. It is in the genes. It is a result of experiencing life in America. It is a spirit, an approach to life. It is a residual of that time when we were

very young and instructed and brilliant, and it is still with us. Everybody in the world admires it. It should make us rich and self-sustaining, but it doesn't.

"We live in a different world now. The arts have been industrialized. They have lost their therapeutic value, and theater is now practiced for the sake of capital. There is also a deficit side to the artist personality. It is, for the most part, a track mind.

"Still, we have a chance to enhance the world in which we live. The African people have a lot to be thankful [for], for our ancestors left a legacy, something all of us can do: express ourselves. It is not something for only a few chosen people. We can all do it, if we want to do it.

"If you have a gift, it is up to you to hold it, embrace it, caress it, protect it, and pump it up. It's not someone else's responsibility. It is something you must do for yourself. But you know, there is so much animosity and anger and hatred that came from the practice of slavery and we're still caught up in it. There are some of us who blame all the tragedy in our lives on other people—always other people—while they themselves are never responsible for anything wrong. Maybe one day we will learn as a people to wear the black hat as well as the white hat.

"For the most part, my career as a singer is forwarded by Jews, Japanese, and European peoples. I appreciate the attention and investment that has come my way from managers and producers who are part of the entertainment industry. I'm thankful for an industry that affords me a way to live and support myself in a world that is for the most part unsupportive of the artist. There is nothing greater to be, if one is black and a female, than a singer. Everywhere in the world we are invited and embraced and expected to be really good. The people keep me alive.

They come to listen and encourage me to be myself and they bring money and give it to the producers who give some of it to me to support myself and live in style and buy spiffy things when I feel like it.

"I like people who come see me who know me, who've heard about me. I'm not anxious for a wider audience. It's a lot more work, and a lot more involved. I like a select audience. That's the way my music is. Jazz is not meant for the masses. It's for the discerning, those who have taste and can understand this approach to music. That's all I want. I don't want a spectacle. Serious music brings a serious crowd, and that's what I want.

"So many jazz folks died young. The lifestyle of the music is dangerous for the musicians and singers because the performers do not embrace the life of a monk or the minister but instead embrace the life of street people, the pimps and whores who have no skills. They find the lifestyle attractive, and it is dangerous, and they overindulge and use things they shouldn't, and they should be brighter than they are.

"People say that's a result of being born black, but that's a lie. Being born black gives you an advantage. There is no deficit in being born black, having African parentage and heritage, because you inherit all these wonderful attributes that is our culture. Some people learn to be jealous and feel that other people have a better life than they have, but I know better than that. This is a common life we all live. We are living on the planet earth and we all know the same things.

"We all have our needs and wishes, and there are very few people who have the inner strength not to fall: to succumb to money, fame, power."

"If you are a victim, you have to look to yourself be-

cause people who are victims all the time need to look inside to try and find out why they are this way most of the time. I was brought up with Bible stories, and that has saved me from a lot of grief by adhering to these kinds of thoughts. We were given instruction and examples to live by and told not to do things, and one of the things we're taught to do is not covet our neighbor. And we are supposed to be kind and not abusive. If there is a God, then I am one who reflects it, like everyone else."

While I was visiting my daughter in Berkeley, California in 1991, I went to see the great jazz bass player Milt Hinton at Kimball's East in nearby Emeryville. I had first met Milt while I was working at *Metronome*, and we had become friends. For eighteen years Milt was the bass player in Cab Calloway's band. After that he was a studio musician in high demand, playing on perhaps five hundred albums by dozens of performers. Jackie Gleason, who made a series of very successful albums, was the first to hire him.

Hinton refused to say that racism brought the jazz age to an end, but he was very concerned that too many of the next generation of black youth were frittering away their opportunities. Milt, who passed away in 2000, was as always charming, attentive, and gracious.

"My grandmother, who raised me, was born a slave in Vicksburg, Mississippi. She was a slave of Joe Davis, Jefferson Davis's father. This lady was a lover of peace, and she had nothing. I never had a pair of skates or a bicycle, but there was always love and concern, and I never missed a meal. As times got better, we moved from Mississippi to Chicago. I remember all those wonderful times. It was just beautiful. All life is beautiful.

"I started taking violin lessons when I was thirteen. I found out that music was the one thing no one except the man upstairs could take from me. No matter how bad things were, I always had music.

"The love and concern which was so important to my life we've now lost. I've seen so much that we've lost our concerns for each other. When I was a kid and anyone in my neighborhood got sick, my grandmother would tell me to take a bowl of soup over there. We seem to have forgotten how this sustains us.

"Cab Calloway was my musical father—not that he is that much older than me, but he stood for so many things. I am proud to have been around him. He stood for decency, respect, and discipline. He carried himself that way, and he insisted that anyone around him be like that.

"We lived in a world of music, and music is an auditory art. We lived by sound, and I don't care where you're from or who your daddy was, we only cared how you sounded. Even in the South in the days of segregation, people came to hear us because we sounded good. The rules of the country said we couldn't sit together, but they could listen together, so that's what we did.

"We played the Cotton Club every night, and we had Dizzy Gillespie, Chu Berry, Doc Cheatham, everybody, and we were heard on the radio, and we were in great demand, even in the South, except that we had to obey the rules wherever we went, and that's what we did.

"I obeyed the rules. I didn't enjoy them, but they came to hear us, and we played for them. We came from New York to the South, and we had these pretty girls in the show with us. Cab was sharp in his zoot suit, and we had these copper colored gals, and it was just beautiful. We came down with this wonderful show giving these people a model to say, 'Hey, this is where we want to be.' We got a

lot of flack for that in those days. The powers that be wanted us to play blues and ragtime that said, 'I'm going to cut your throat if you drink my wine,' but we refused to do that. I can't tell you how close we came to being lynched sometimes. Really close, because the people never saw a show like ours.

"But the powers that be kept us out of a lot of places, and that was one of the reasons Cab's band finally had to break up.

"We weren't angry at the way we were treated as much as disappointed. I don't know any other country but this one. I was born here, so I felt badly I wasn't treated the way everyone else was treated. You know, you can't play music angry. We used to laugh at people asking us to do certain things. I would take pictures of my wife, Doc Cheatham, and other guys in front of a hotel sign that said, 'For Colored Only.' We had come from New York where things were great for us, and we came down South and everything was just silly. I was taking these pictures of the silliness, hoping in later years the young people would see what a stupid thing it was, and that's what happened. I'm glad I took them, and I'm glad young people have a chance to see them. To show the dues we had to pay in order to play our music.

"When the big bands broke up, there was no more big-band work, but I got lucky. Thanks to Jackie Gleason, I got into recordings and I began to make good money. Jeff [Hilton Jefferson] was working down in Wall Street. Cozy Cole was trying to form a little band. We would meet every Monday at Beefsteak Charlie's at five when Jeff got off. Quincy Jones, Oscar Pettiford, Jeff, and all of us would be standing at that bar. We would put our change up on the bar. We'd just drink and laugh and talk until it was time to go home. I wanted to take Jeff and Cozy down to Mexico for a week's vacation, because I had the money, but they had too much dignity, and we never did it. It is one of the greatest regrets of my life that we never made that trip.

"Jazz is not embraced by the general population because it's ours. We have a tendency to lose respect for what is ours. Why do we buy so many Japanese cars? Man, my house is loaded with everything made in Japan. Very few things are made in America any more. It's sad. The young jazz musicians today make more money abroad than they do at home.

"You can't make everything to be a race thing. We have become complacent about being efficient. We could make better cars.

"My mother had a short fuse. You know, you either do it, or forget it. Man, I never had a pair of skates or a bicycle, but you can't miss what you never had. But you want your children to have what you never had. But you must learn to earn. It's a difficult thing for young people today to realize this. They think everything is easy. There is no question that Japanese things are better than our things.

"I teach at Baruch College. It's a business school with a small music department. The school is seventy-five percent oriental. Where are all the American kids in business? And that music class I have is a small class: eighty-five percent Asian. I find it very difficult to entice some of the black students to make some progress, because they don't see where they are going in the future. They don't have any role models.

"I play to white audiences all the time. Black kids don't come to see me. They don't know whether I'm successful or not. When Cab Calloway was around, they could see it. When Duke Ellington was around, they could see it. They

could say, 'Hey, I want to be like that.' We play these places where the price of admission is high, and they don't come see us.

"The young black kids are into rap, saying things we don't want to hear. I won't condemn them for saying it. That's poetry, man, and it's great. They're saying it the way they see it in a language they know.

"These black kids don't have the bread to come to a place like Kimball's East. More whites can afford tickets. That's the real reason the audience is mostly white."

8 Switzerland

Through the efforts of drummer Oliver Jackson, for three straight years I was invited to attend and photograph the Bern International Jazz Festival. The concerts were produced by Hans Zurbrugg, an amateur trumpet player (and banker) who told me he would invite Dizzy Gillespie back to Switzerland any chance he could get given how very special Dizzy was as a player and human being. The public persona—always happy-go-lucky, smiling, joking—is sometimes different from the private side and John Birks (Dizzy) is a good example of this. For all his funny antics, Dizzy was a very serious fellow, committed to his music and his religion (he was a Bahai) and to bringing great music before his adoring public.

Dizzy was the closest of friends to Charlie Parker, the mercurial alto-saxophonist of the forties and fifties who died at the age of thirty-five, yet looked as if he were sixty. Dizzy, who never engaged in drugs, tried his best to get Parker off drugs—to no avail.

I'm jumping ahead of myself here. As I explained earlier, Oliver Jackson was someone I knew back in the late fifties, early sixties as a wonderful drummer and human being. We hung out together then. It took twenty-five years for us to catch up to each other, which we did when I went to Switzerland with Nina Simone. Oliver convinced Hans Zurbrugg that I was the best jazz photographer in America (not true) and that I should document his festival in 1987. I was hired to cover the 1987 jazz festival and returned the next two years as well.

The festival takes place every spring, the weather warming, the grass turning green with the faraway mountains still covered with snow. The Swiss had an honest, no-nonsense attitude, cleanliness, punctuality, and a total absence of humor. A Swiss comic would be a contradiction in terms, but they sure love their bebop and blues, as the festival is sold out for five straight evening concerts that last well past midnight. It was more or less a "straight ahead" festival, with many of the performers the very backbone of the jazz world. There were others whom I did not know but they soon became some of my favorites. Being there in Bern also brought me into contact with many men and women whom I knew from the old *Metronome* days: blues singer Joe Williams, trombonist Slide Hampton, Newport Jazz Festival producer George Wein, Sarah Vaughan, trumpeter Clark Terry, pianist Horace Silver.

One early evening before the concert, I went out for a spaghetti dinner with Joe Williams and a number of other folks, and we had a wonderful time. Joe was holding court, putting people on, the usual jazz dinner, with everyone relaxed and in good spirits.

I had briefly met Joe Williams when I was working for *Metronome*. He had replaced Jimmy Rushing as the singer

in the Count Basie Orchestra in the mid-fifties. He then left Basie and formed his own trio. Joe sang the blues like no one else. I have to admit he was my favorite male jazz singer.

That night in Bern, Joe was on a bill with another great singer, Carmen McRae. Always independent, Carmen had also come on the scene in the fifties. I made photographs of her in Switzerland and later at the Newport Jazz Festival. She told me one of my photos was the best she ever saw of herself.

At the end of that evening's concert, Joe and Carmen were walking down a long hall backstage, ready to split for their respective hotels. Carmen I had known from afar, and Joe was someone closer, and when they were together Joe greeted me as a friend, and I was able to make use of his ease and openness. The photo I made of the two of them was memorable.

Later I would see Joe at festivals, where we would chat, talking about life and loves, and we'd move on. For a jazz musician the road is their home most of the time. It's like what trumpeteer Ted Curson said about one of his tours: "Man, you play the gig, get on the bus, move to the next town, wake up with a different ceiling in your face, wash, eat, dress, play the gig, and move on again. After six weeks of this, you get a little tired." A little tired? I'd be exhausted after two days. For a jazz musician, stamina was almost as important as talent.

One characteristic of jazz performers is their physical durability. The music can become very quick, the notes rolling off the tongues, and it takes a certain level of endurance to not only play but to stay in tune. To see this happen with young musicians is expected; to see it happen with middle age and older musicians is truly remark-able. So many of the men and women I met while covering the Bern Jazz Festival are still out there, still making music: singer Dee Dee Bridgewater, trumpeter Jon Faddis, bluesman Buddy Guy (a story in its own right). Upon my return to America in 1989, I put together a wonderful exhibition that opened at the Verve Gallery in Los Angeles in 1990. Buddy's image was in the show, and by chance one of the producers of "Damn Right I Got The Blues," the new Buddy Guy record worked it out with the gallery owner, Bill Goldberg, for me to fly to Chicago and make the image that eventually appeared on the record cover. Never was I so cold in my entire life, going to Chicago in December 1990. I spent a weekend at Buddy's blues club listening to wonderful music.

I was set to leave Chicago the next day but I also wanted to see the Picasso sculpture in front of the stock exchange, so I left the hotel early and began to walk to where the sculpture was located. It turned out to be a terrible mistake as I had no hat and my jacket wasn't that warm and the weather was nasty. Halfway to the Picasso piece I turned around and hurried back to the hotel as quickly as I could, getting colder and colder by the minute. Not one to ever take a drink in the middle of a morning, I hurried to the bar. Thankfully, it was actually open, ready for business. I asked for something that would warm me up as quickly as possible. Mission accomplished, I then headed out to the airport, never so glad to leave Chicago. Sadly, I have never returned to Chicago, but, from the many friends who not only vacationed there but also lived there, I know that Chicago is a "happenin' town." Someday.

Anyway, returning to the Bern Jazz Festival of 1987, it was a who's who of great talent and funny stories: The Blind Boys of Alabama, saxophonist Al Cohn (a real gentle-

man and one of the funniest persons I have ever known), saxophonist Scott Hamilton, and trumpeter Nat Adderley, the younger brother of Cannonball Adderley. Nat and I eventually became "neighbors" when I moved to Florida in 1992, as he lived in Lakeland, Florida, not far from my home in St. Petersburg.

The star of the 1987 Bern Jazz Festival was Sarah Vaughan. Knowing she was to be there, I brought along a small print of a photograph I made many years before of a young Sarah Vaughan singing with O. C. Smith of the Count Basie Band, an image I made at the old Birdland. Sarah did not recognize O. C. when she saw the photograph and I was not about to tell her the story of how she "killed" O. C. in thirty-two bars, a story I have told elsewhere.

Being in Switzerland for the second time was a trip all by itself. The Swiss are certainly fastidious, neat, clean, punctual, and extremely honest. I thought I could leave my camera bag next to a lamppost, walk around the block, and return to find my bag still there. I recall an incident in New York City when in fact I did leave my suitcase, by accident, next to a lamppost and, discovering the absence, immediately returned to the corner, to find my suitcase gone—all within the space of no more than two minutes.

The Swiss people that I met—all involved with the jazz world—were open, engaging, and very knowledgeable and they treated me with great respect as an artist. I had very few occasions in New York where I was treated as an artist because of what I did for a living. I felt very special.

Also, being in Switzerland enabled me to reconnect with Allan Porter, the former editor of the magazine *Camera*, a well-respected magazine publishing some of the worlds finest photographers. Allan and I went to the same Philadelphia high school and art college. He spent a few years in New York and had been for the past forty years a resident of Switzerland. It was a wonderful meeting and I continued to see him when I returned to Bern in 1988 and 1989. We have remained in contact through e-mails and telephone conversations. He continues to photograph and write about photography.

I returned home after a week's worth of great music, anticipating my returning in 1988, wondering which musical artists Hans would seek out for 1988.

I did return in 1988 (and 1989) and I brought along a tape recorder, enabling me to record some of the music played by the Count Basie Band under the direction of Frank Foster, a great tenor saxophonist, heading the band since Basie's death. Clark Terry introduced me to B. B. King, with these words, "Herb, you will never meet a man who is more of a gentleman than B. B." He was so right. What a generous and thoughtful man he is, still out there, still making audiences cheer. He is so very special to the blues and jazz communities. And of course his performance was "totally out of sight." He brought the stoic Swiss to their collective feet, continuing to cheer until he appeared on stage to take another bow.

One of the other wonderful occasions was meeting and photographing the renowned stage and film actor Burgess Meredith, a jazz fan who stayed the entire week digging the music and socializing with musicians every night, backstage. He was so unassuming and allowed me to make a few images along the way. One of the performers, totally without fanfare, also brought the house down: Maxine Weldon's time on stage was exciting to watch. She was just terrific. Maxine was an unknown (to me) singer

from Los Angeles who continued to reinforce my feelings that there are so many talented people in this world who go through life making music, making art, who simply never receive the attention they deserve. Maxine is one of them. I loved speaking with her; she was not only a quality person but also a really talented singer.

I have always wondered what ever happened to her over all these years, twenty-one years to be exact. The 1988 Bern Jazz Festival ended with performances by Lionel Hampton, Joe Williams/Carmen McRae, and the great pianist Oscar Peterson. Once again I returned home with a bundle of money, some valuable tapes, and a desire to sleep for a week to make up for the too many nights of parties. Jazz musicians certainly know how to have fun!

Before leaving for home Hans and I had a conversation about my having an exhibition of work made at the 1987 and 1988 festivals; a one-person show situated at two venues, one of them being located at the upscale hotel at which the more well known musicians were staying. The other was at the performing arts center; both exhibits got high visibility out of which came a number of sales—very gratifying to say the least!

But 1989 was the last year I was able to return to Switzerland as the festival's main underwriter (a Swiss bank) pulled out and there went my opportunity to be part of any more Bern Jazz Festivals. It was a grand three-year ride, 1989 was the best of the three years, filled with great music from pianists Michel Camillo and Hank Jones; the great drummer Art Blakey and his Jazz Messengers; the steady jazz bassist Milt Hinton (a wonderful photographer, too); bluesman Albert King; trumpet players Freddie Hubbard and Tom Harrell; the always energetic singer Dee Dee Bridgewater; clarinetist Buddy DeFranco (still alive and cookin'); the composer and saxophonist Benny Golson. Freddie and Benny years ago were part of the early sixties band of Art Blakey and the Jazz Messengers—so the festival was a small sort of reunion for them both.

Freddie is no longer alive, while Benny is still blowing, still composing, for which we can all be thankful. The Detroit-based Moss Family Singers brought the festival to a close, and with it my time in Switzerland. But thousands of negatives and prints are within my archives and many of the images will last long into the future, testifying to a time of great music, three weeks in three years, among creative people wishing to do no harm but rather to bring into the world all that is positive and life affirming. I was proud to be a part of those times.

After the last concert of the 1989 festival, trumpeter Clark Terry and I were sitting backstage. We were tired, drained from a week's worth of concerts, long hours, hard work, and too many parties. Clark looked at me, and I said, "Hey, Clark, what's up?"

He said, "You know, Herb, I've been thinking, you've been at this as long as we have." I thought, *Oh no, Clark. You're much older than I am.*

I was touched. His music and my images relate to a particular time and place, where blacks and whites—finally—came together, however haltingly.

The next morning many of the musicians and I took a bus to the Zurich airport. They were off to other places, other gigs, festivals, or small clubs throughout Europe. The ride was filled with laughter, warmth, comradeship, good vibes. Albert King and his band were aboard, as were Milt and Mona Hinton, Dave Berger and his wife, Holly Maxson. Ruby Braff, the great grumpy cornet player, was also on board, as were the Moss Family Singers.

The sun was warm, and it wasn't long before most of the musicians were sound asleep. I always admired how musicians can fall asleep wherever they are, sitting or leaning.

We arrived at the airport, hugged, said good-bye, and since I was the only one flying to Boston, I found myself alone, thinking about my life, my friends, and the wonderful music I had just heard—a nice way to make a living.

Louis Armstrong with the Star of David on his chest, Tanglewood, MA, 1960 >

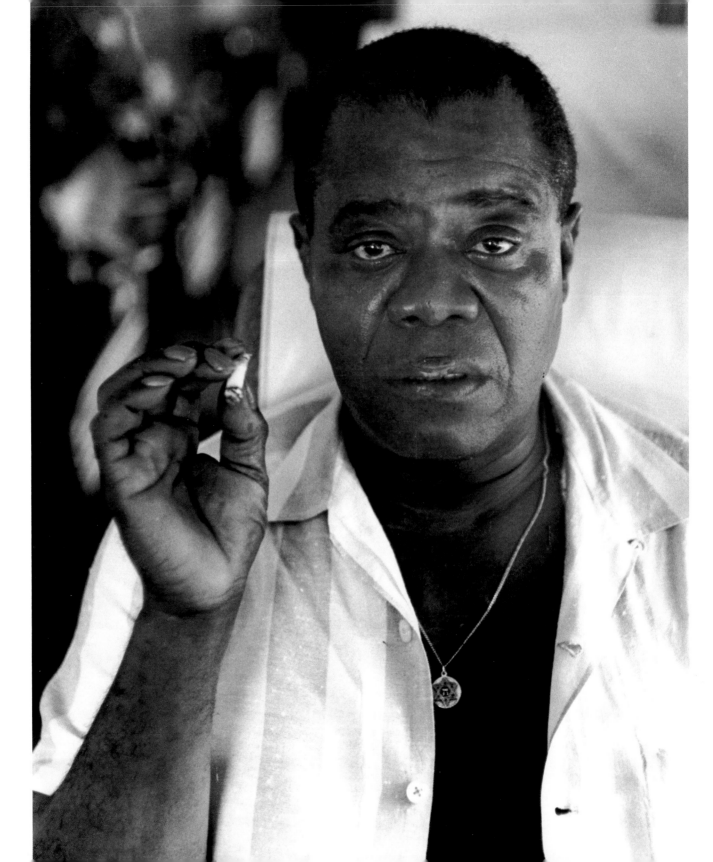

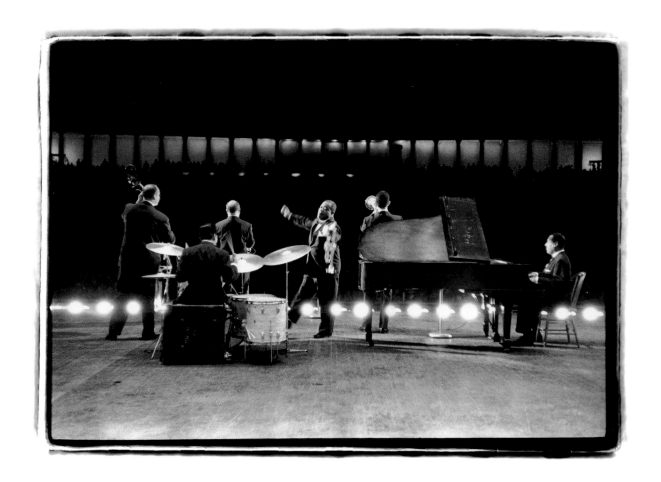

Louis Armstrong, band, Lewisohn Stadium, NYC, 1960. From left to right: Mort Herbert, bass; Danny Barcelona, drums; Barney Bigard, clarinet; Louis Armstrong, trumpet; Trummy Young, trombone; Billy Kyle, piano

< Louis Armstrong trumpet and handkerchief, 1960

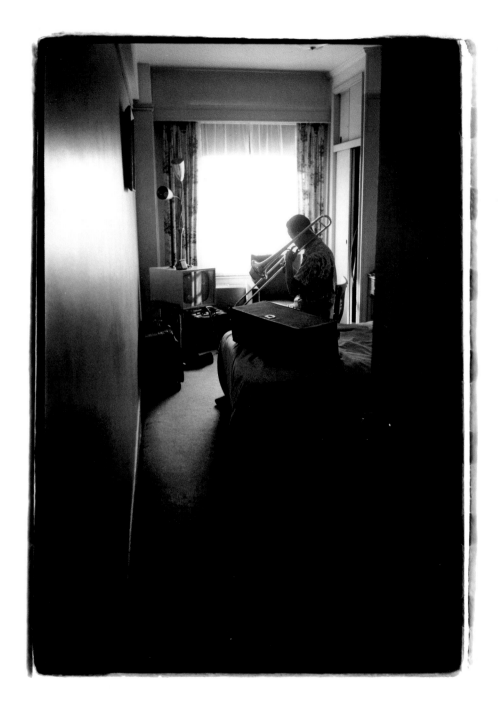

Trombone player Trummy
Young, of the Louis Arm-
strong band, in a NYC hotel
room, 1960

Singer Velma Middleton
performing with the Louis
Armstrong band, Tangle-
wood, MA, 1960 >

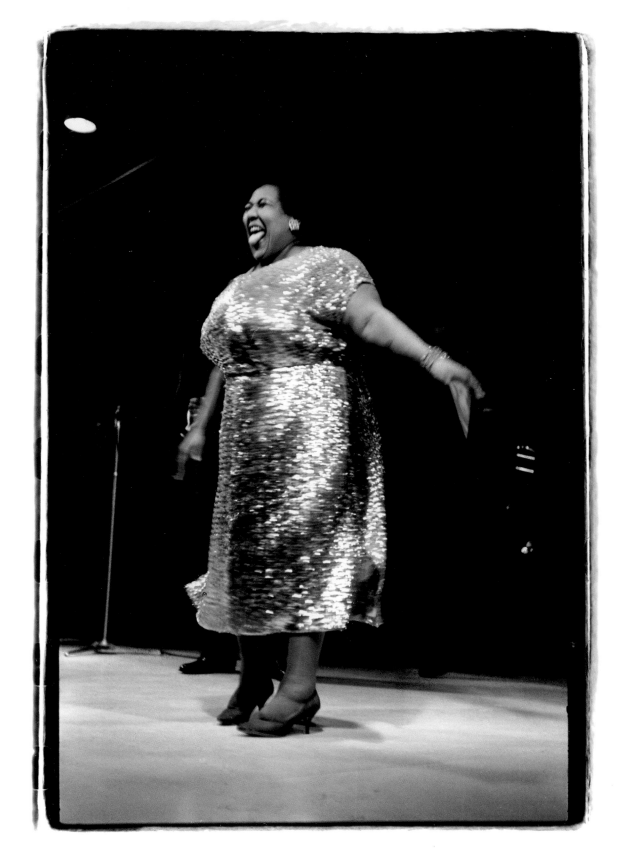

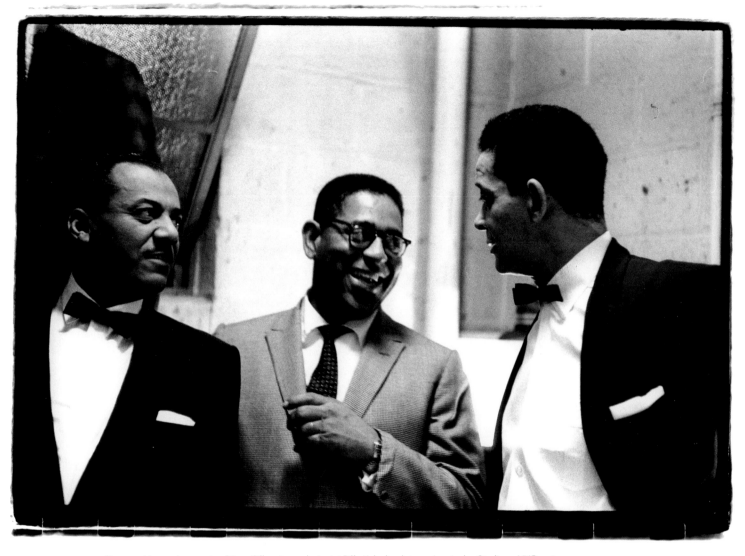

Trummy Young, trumpeter Dizzy Gillespie, and pianist Billy Kyle, backstage, Lewisohn Stadium, NYC, 1960

< Trummy Young in NYC parking lot, 1960

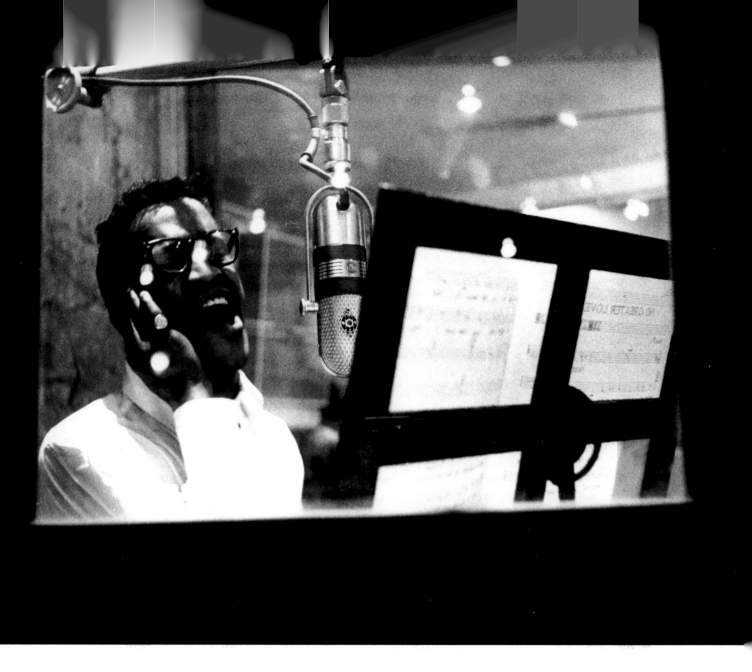

Sammy Davis Jr. singing "No Greater Love" with the Basie Band at a NYC recording studio, 1960

Trumpet player Clark Terry, NYC, 1959 >

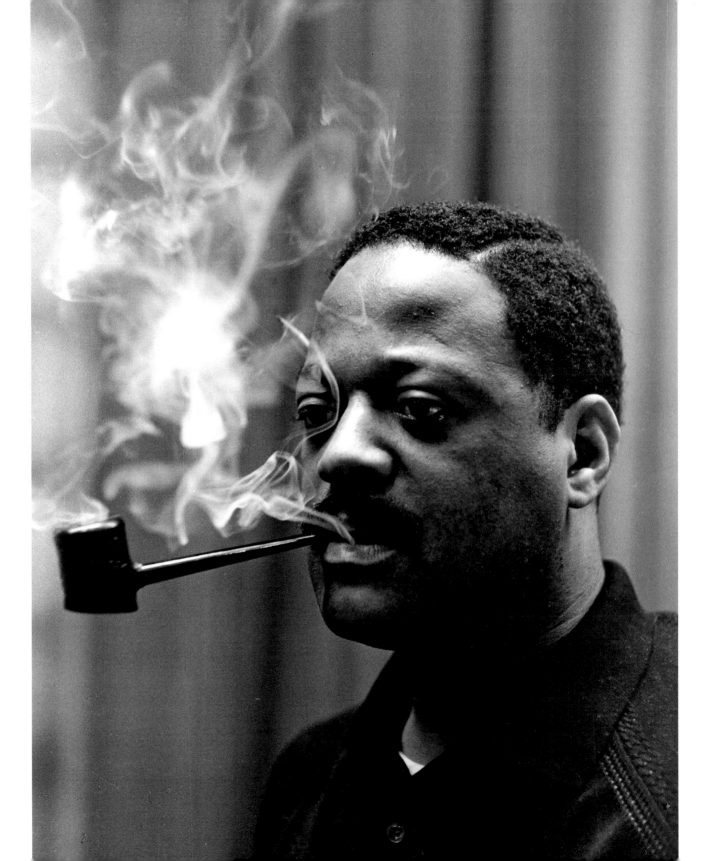

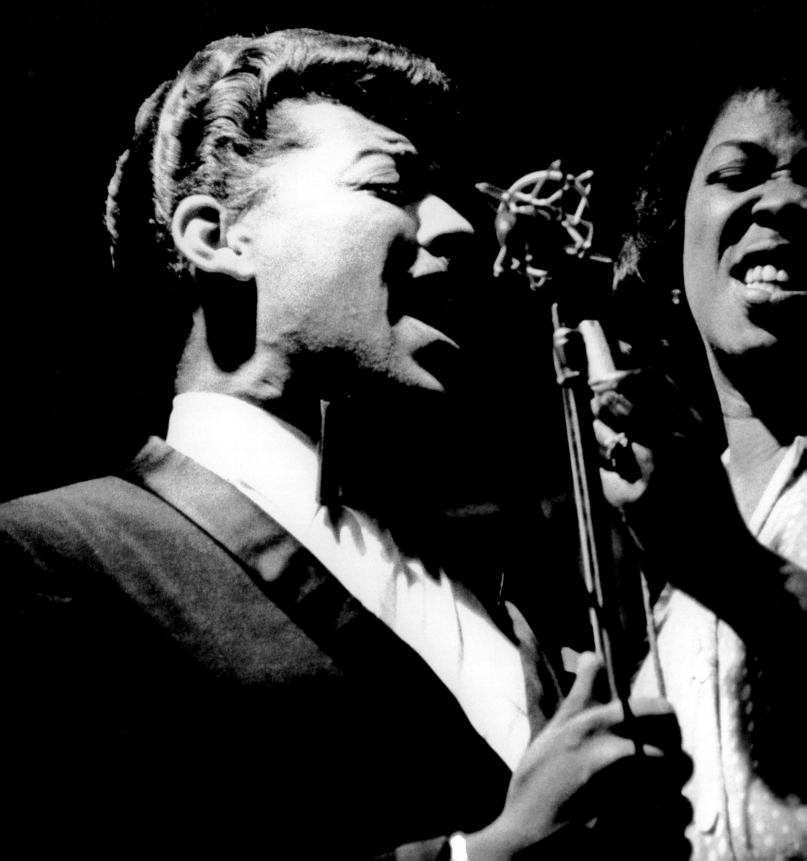

Sarah Vaughan, backstage, Bern International Jazz Festival, Switzerland, 1987

< Saxophonist Lester Young and
Hank Jones outside Five Spot Café,
NYC, 1958

Lester Young, Five Spot Café, NYC,
1958

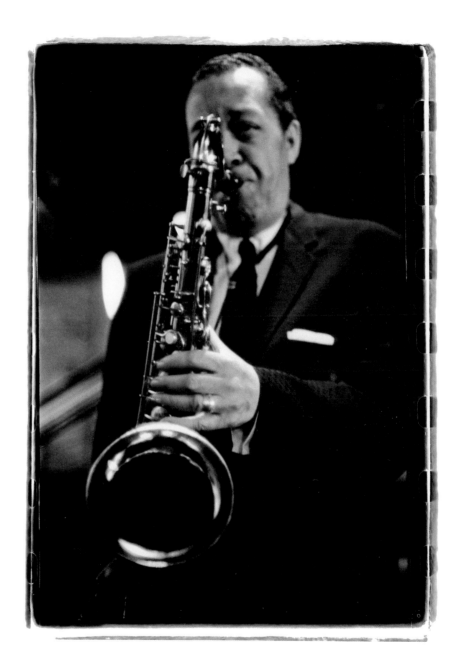

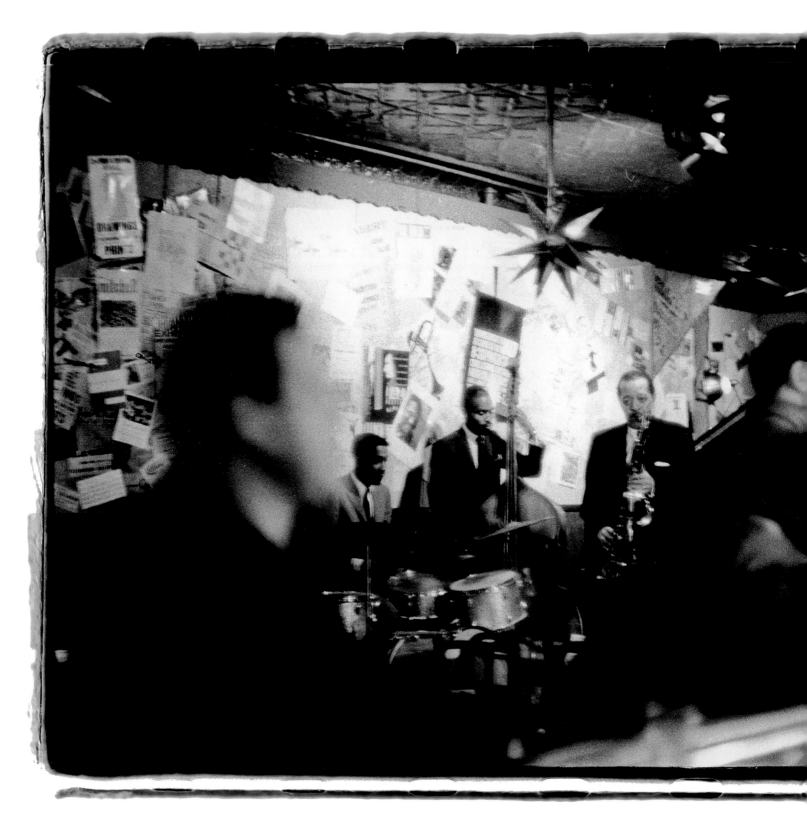

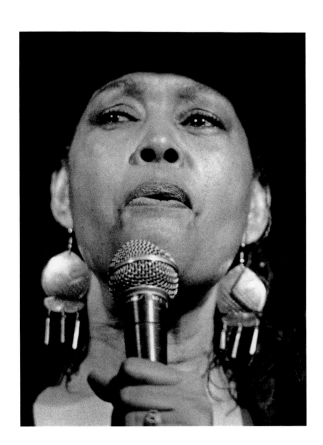

Abbey Lincoln, Cambridge, MA, 1990

Lester Young, Five Spot Café, NYC, 1958

Sheila Jordan at her home in the "bird room," Newburgh, NY, 1991

Odetta, WGBH TV studio, Boston, MA, 1990 >

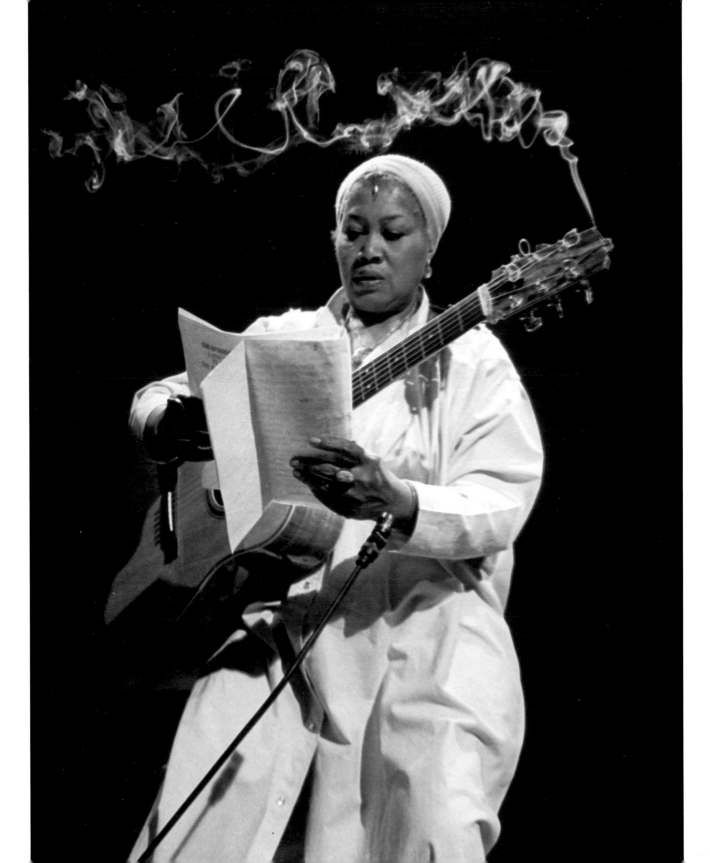

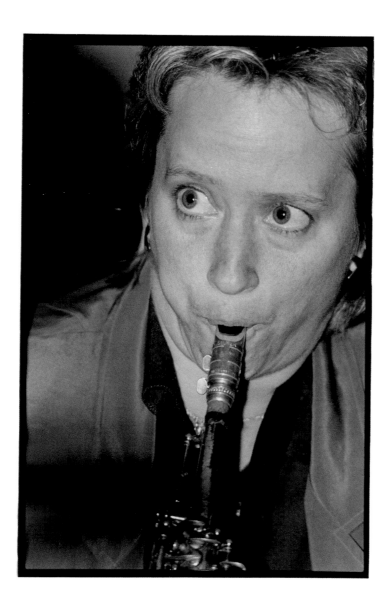

Jane Ira Bloom, Cambridge,
MA, 1991

Saxophonist Coleman Hawkins, Museum of Modern Art, NYC, 1960 >

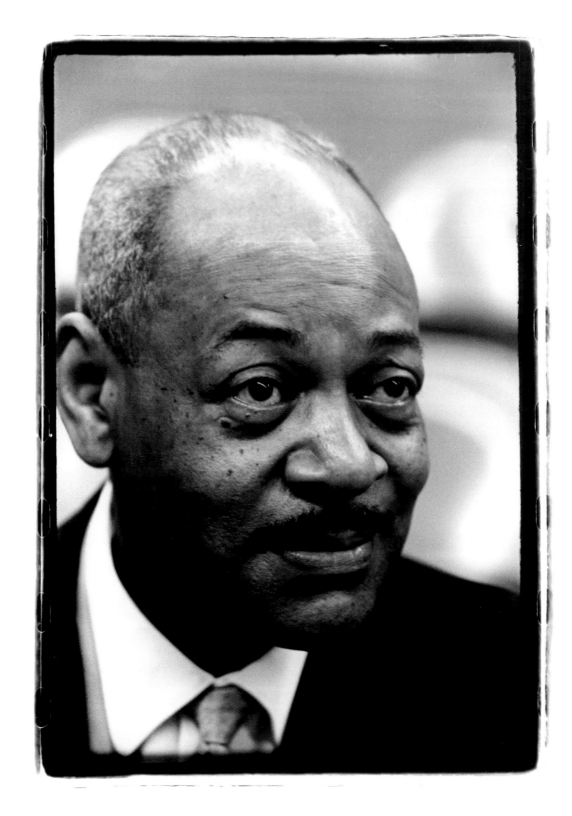

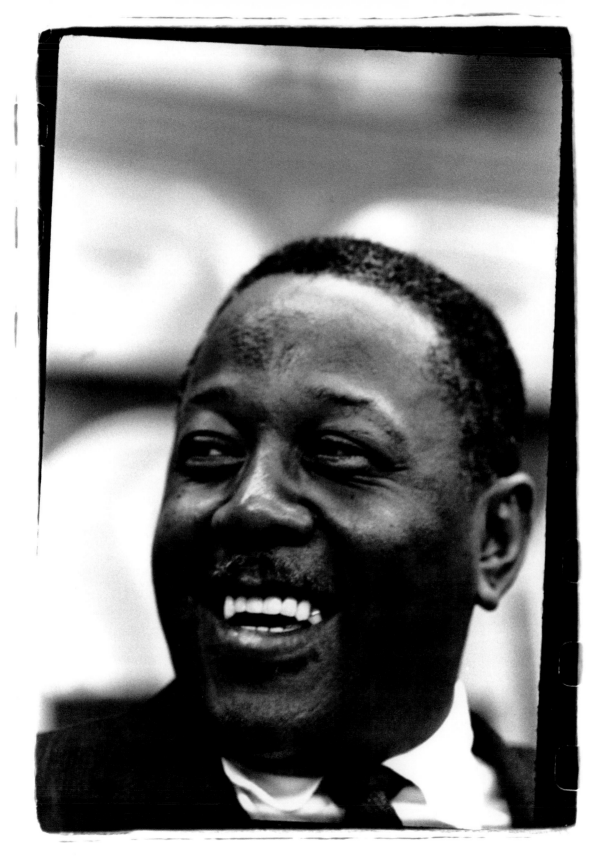

< Trumpeter Roy Eldridge,
Museum of Modern Art, NYC,
1960

Bassist Jimmy Garrison, back-
stage, Village Gate, NYC, 1961

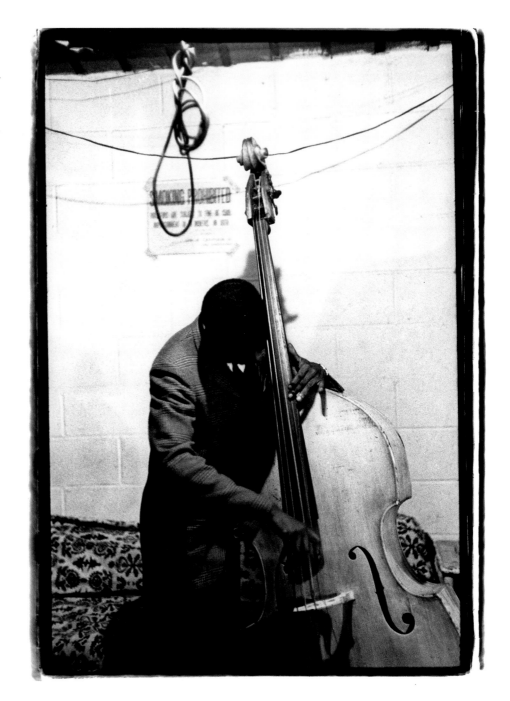

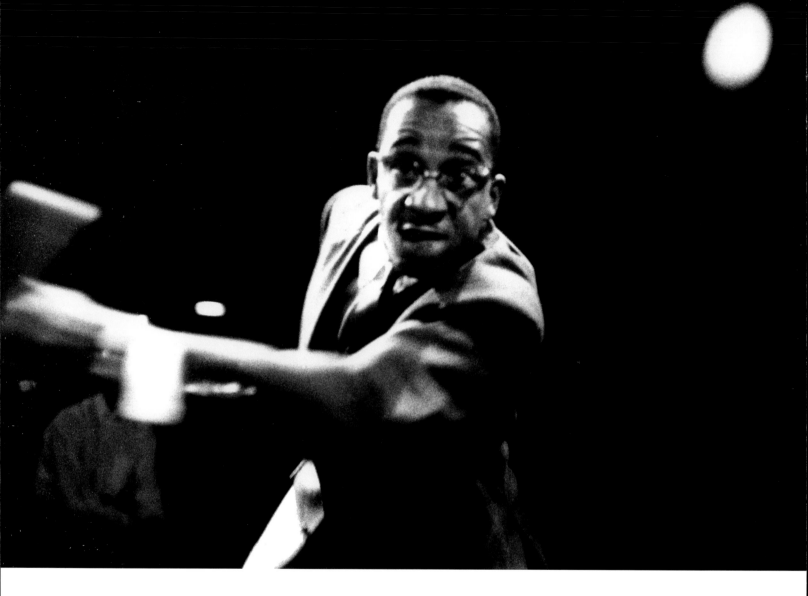

Milt Jackson of the Modern Jazz Quartet playing ping-pong, NYC, 1960

Bassist Eddie Jones, Count Basie Band, NYC, 1960 >

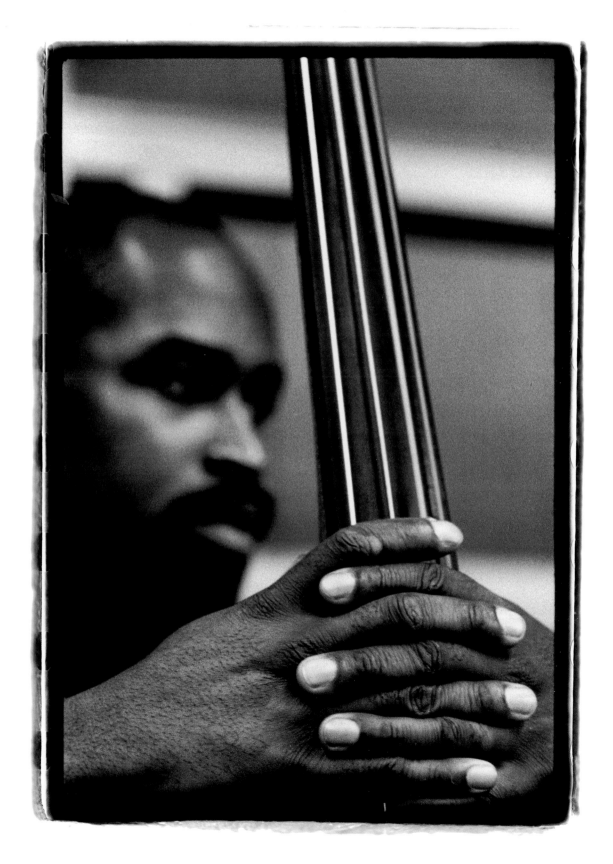

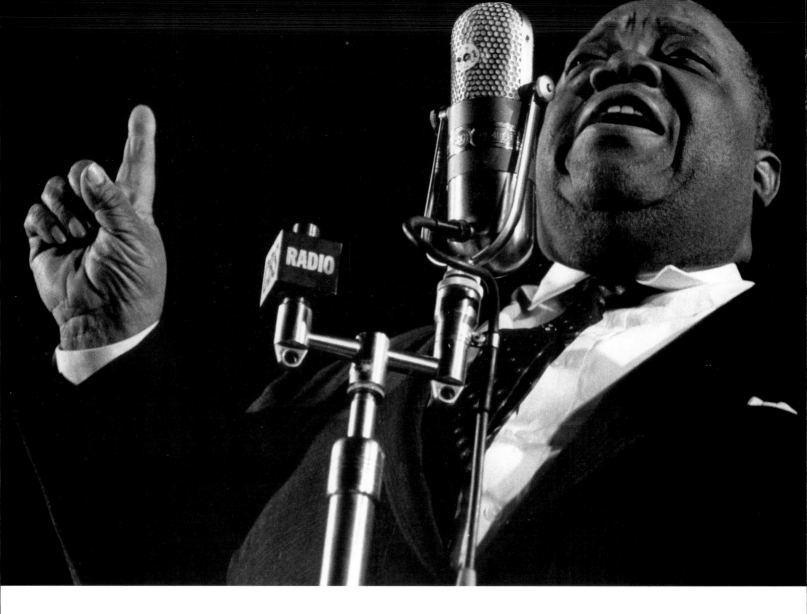

Singer Jimmy Rushing performing with the Duke Ellington orchestra, Randall's Island Jazz Festival, NYC, 1959

Trumpeter John Birks "Dizzy" Gillespie, Hunter College, NYC, 1959 >

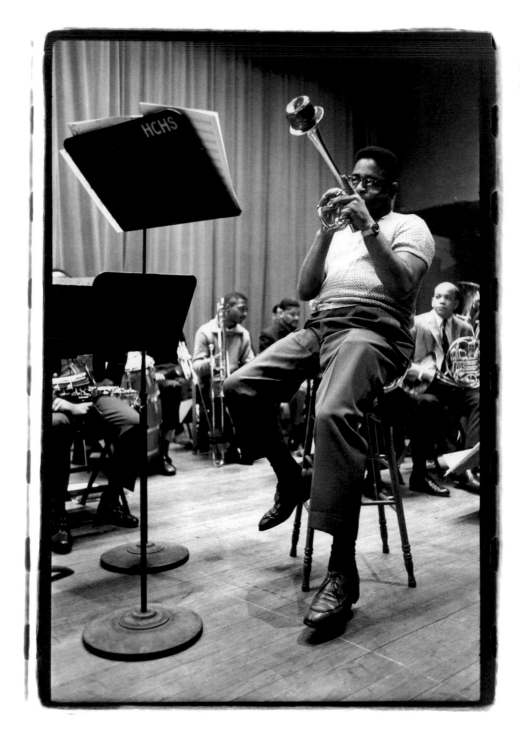

Dizzy Gillespie, Hunter College
rehearsal, NYC, 1959

Singer Nina Simone, Philadelphia, PA, 1959. Photo used on cover of her album, *The Amazing Nina Simone* (Colpix Records) >

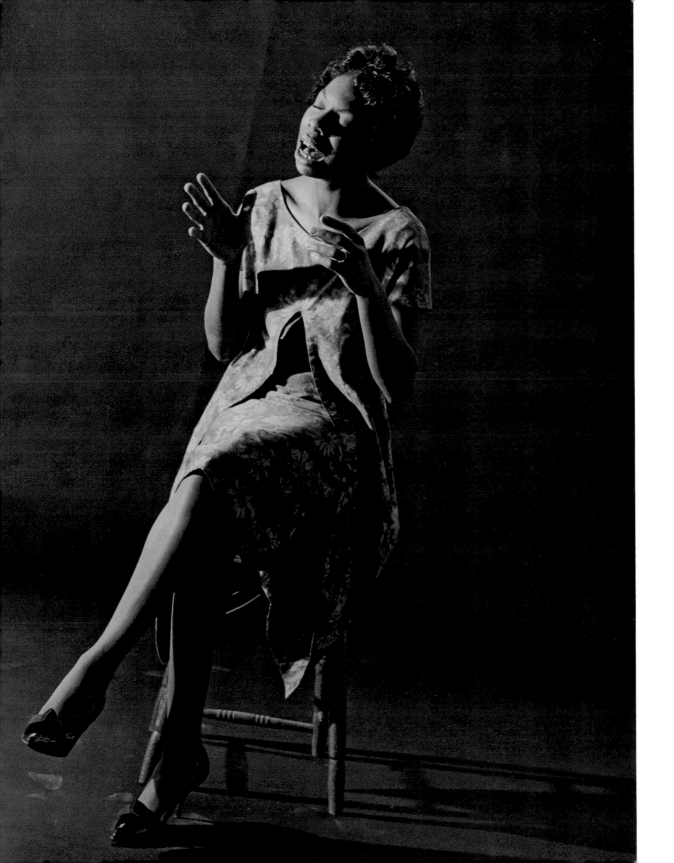

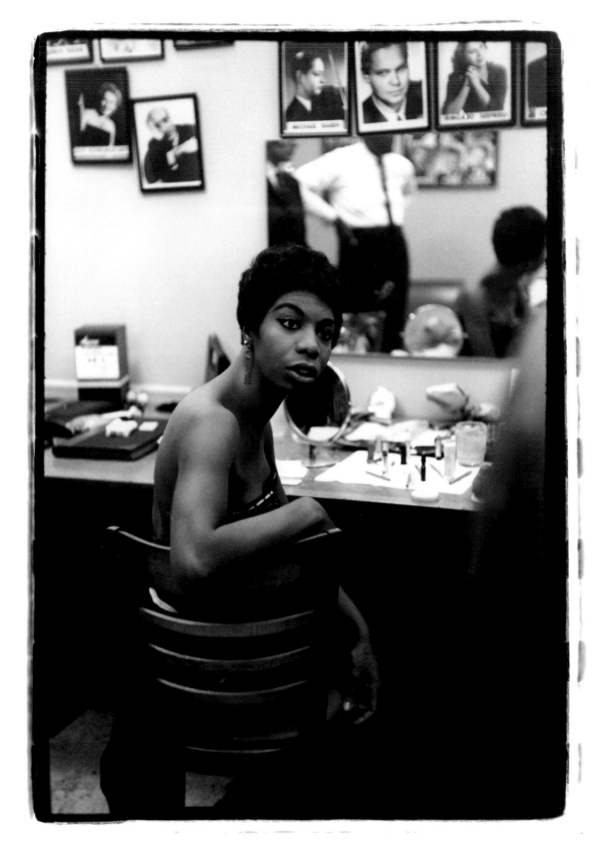

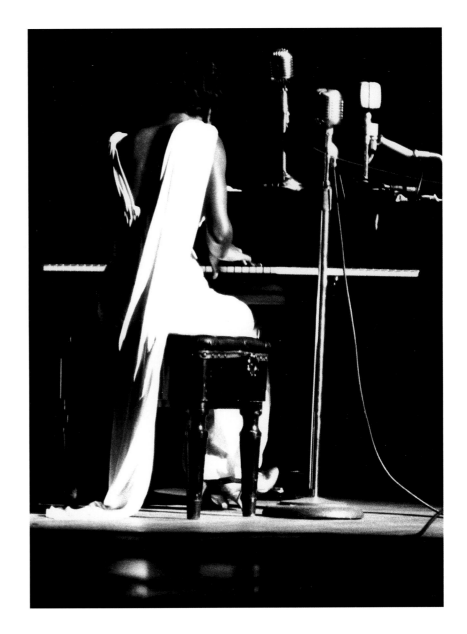

Nina Simone, performing, Town Hall, NYC, 1959

< Nina Simone, backstage, Town Hall, NYC, 1959

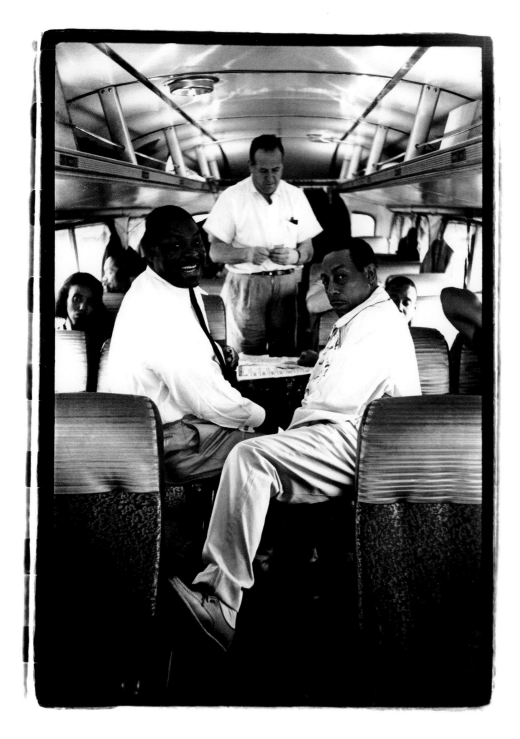

On the Duke Ellington bus: saxophone players Cat Anderson (left) and Johnny Hodges (right) playing cards, NYC, 1961

Duke Ellington, Jimmy Hamilton, Columbia Recording Studio, NYC, 1961 >

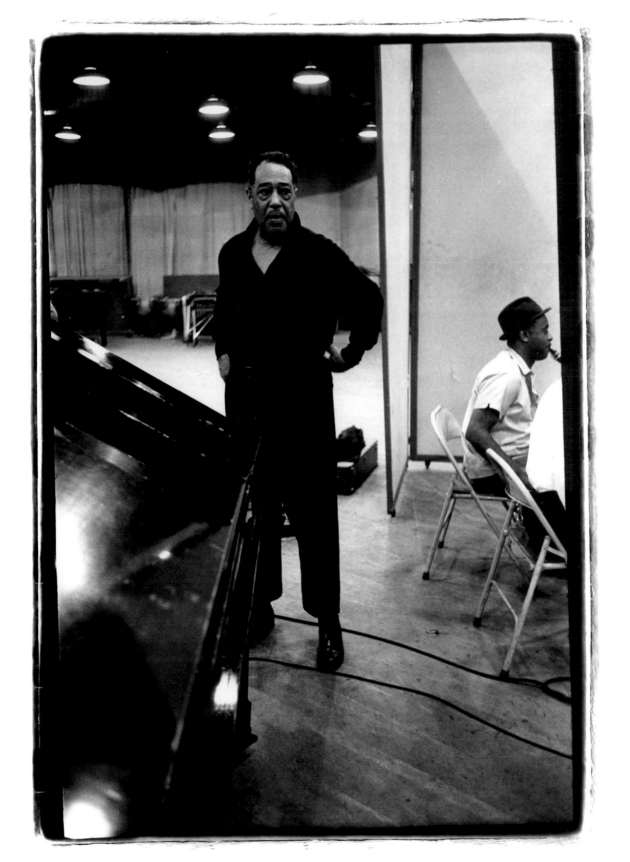

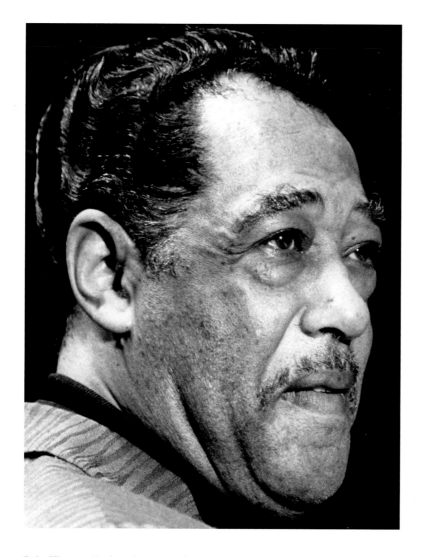

Duke Ellington, Madison Square Garden Jazz Festival, NYC, 1960

Duke Ellington, Madison Square Garden Jazz Festival, NYC, 1960

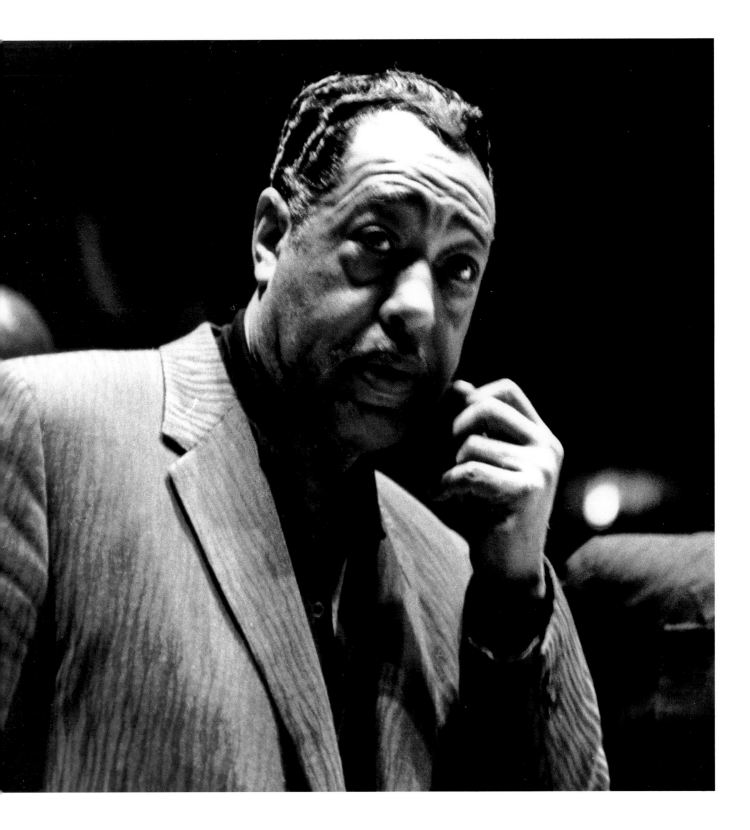

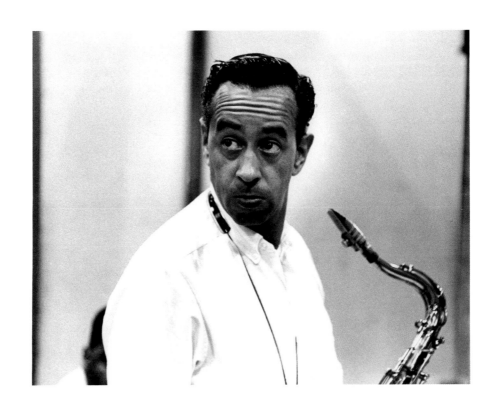

Saxoponist Paul Gonsalves of the Duke Ellington Orchestra, Columbia Recording Studios, NYC 1961

Saxophonist Johnny Hodges,
Columbia Recording Studios,
NYC, 1961

facing page: Johnny Hodges,
Columbia Recording Studio,
NYC, 1961

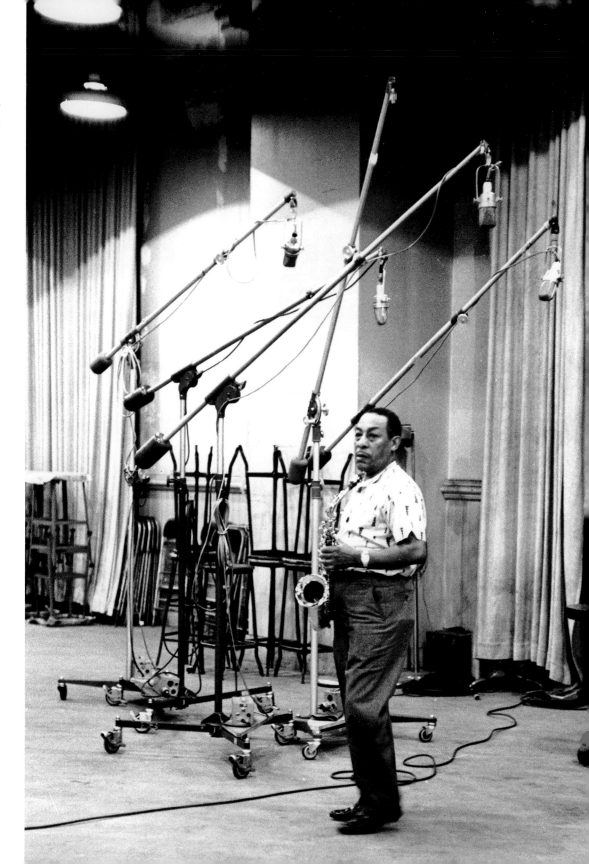

Saxophonist John Coltrane,
backstage, Village Gate, NYC,
August 1961

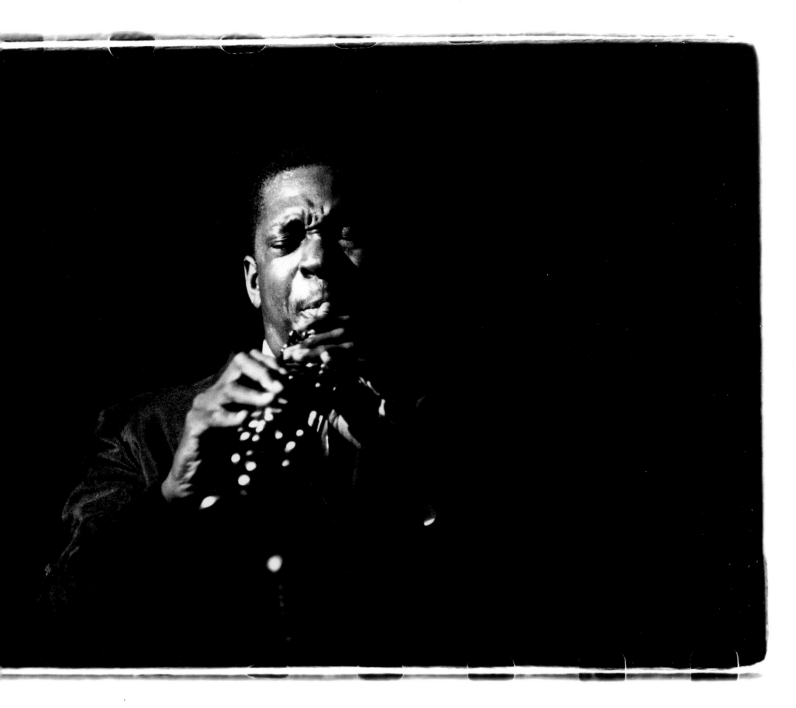

Saxophonist John Coltrane performing at Village Gate, NYC, August 1961

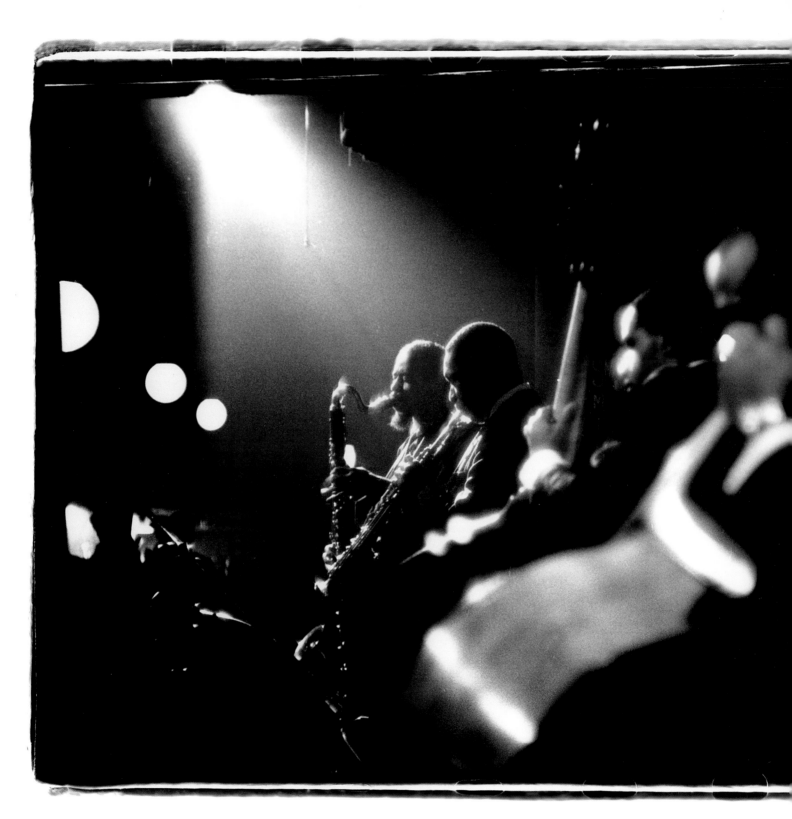

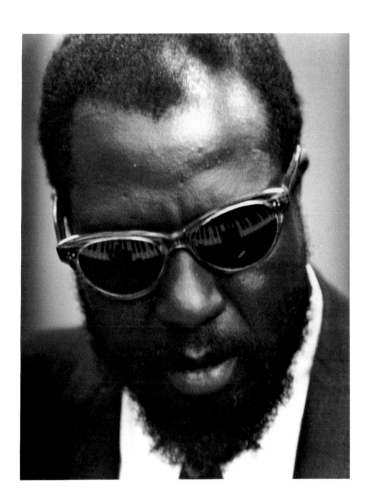

Pianist Thelonious Monk with keyboard reflected in his glasses, United Nations, NYC, 1960

Saxophonist John Coltrane and bass Clarinetist Eric Dolphy with bassists Reggie Workman & Arthur Davis, Village Gate, NYC, 1961

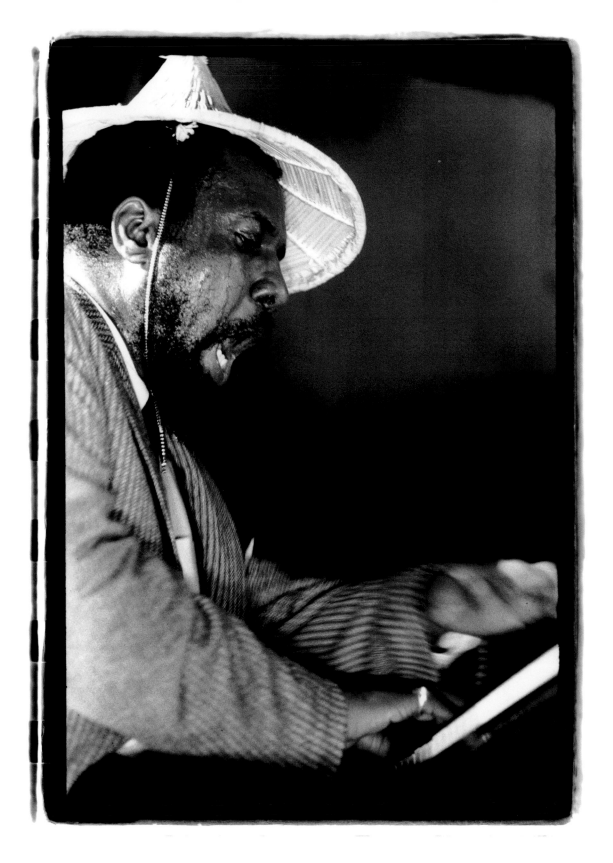

< Pianist Thelonious Monk,
Randall's Island Jazz Festival,
NYC, 1959

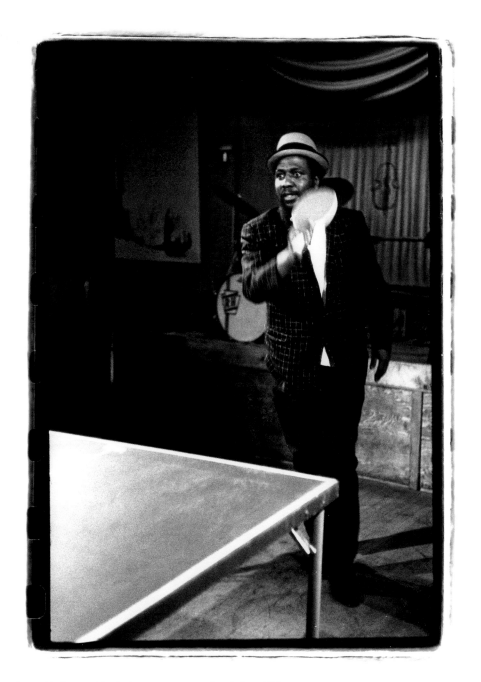

Pianist Thelonious Monk playing ping pong, Jazz Gallery, NYC, 1960

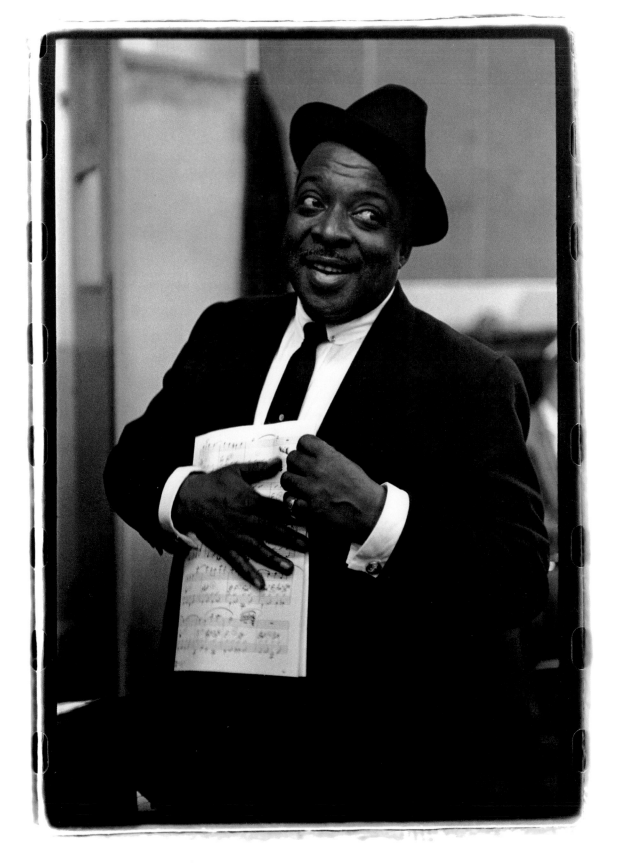

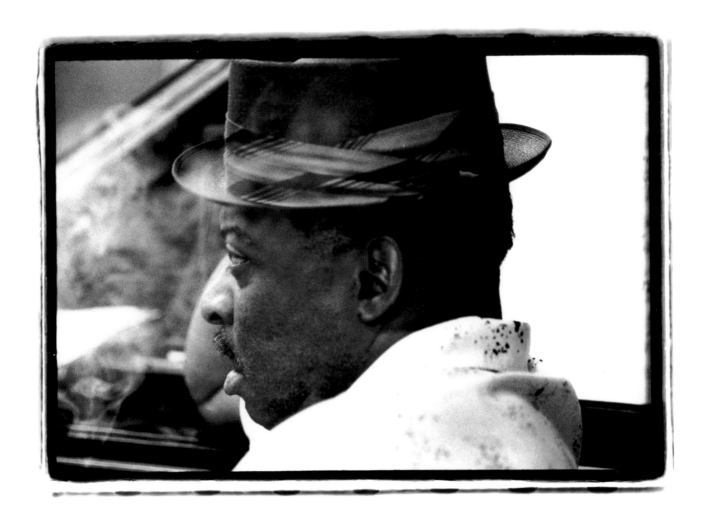

Bill "Count" Basie, Roulette Records recording session, NYC, 1960

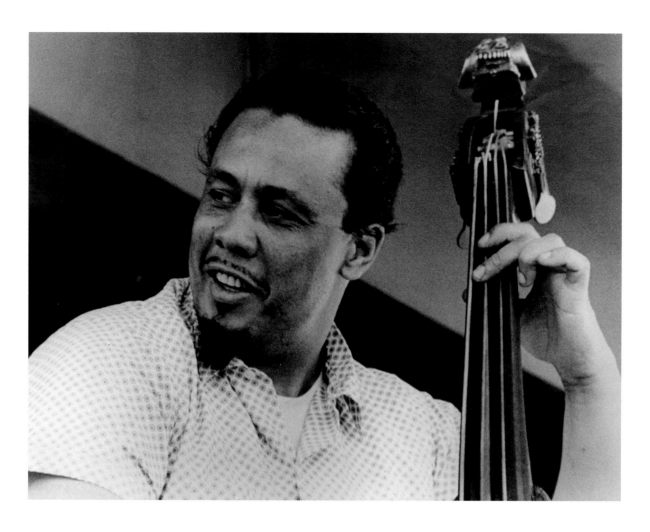

Bassist Charles Mingus, Newport Jazz Festival, Newport, RI, 1959

Trombonist Henry Coker, Count Basie Orhcestra, Recording session, NYC, 1960 >

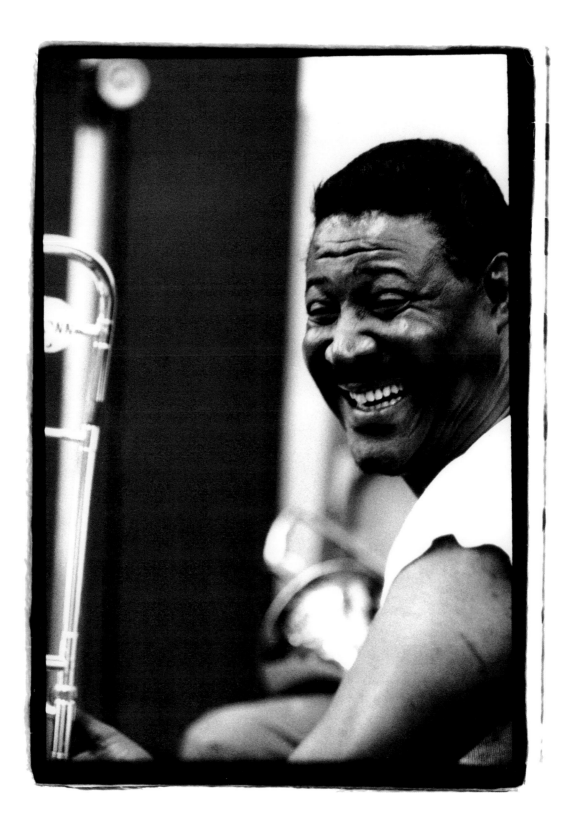

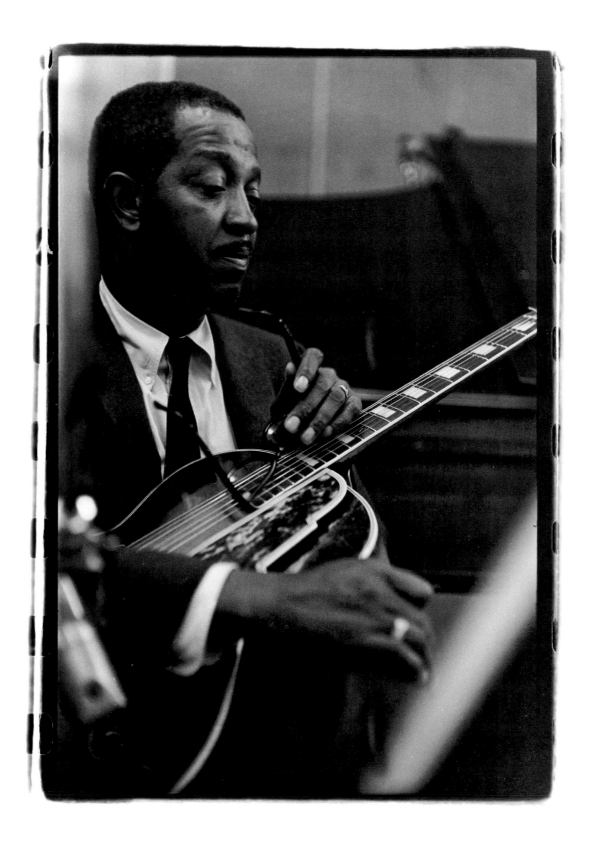

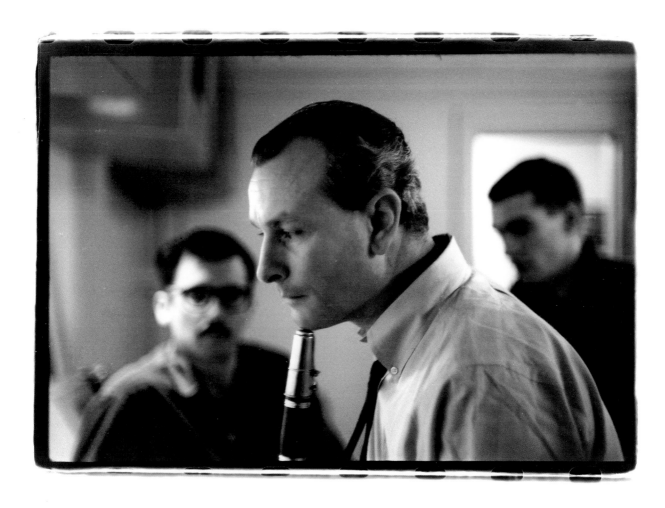

Clarinetist Jimmy Giuffre, pianist Paul Bley, bassist Steve Swallow, recording session, NYC, 1962

< Freddie Green, Basie Band, NYC, 1960

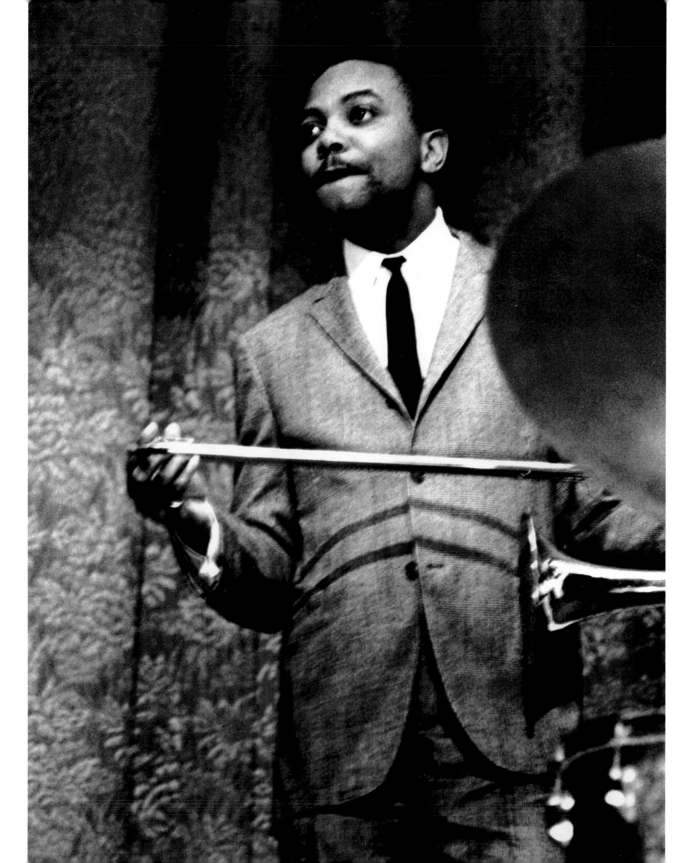

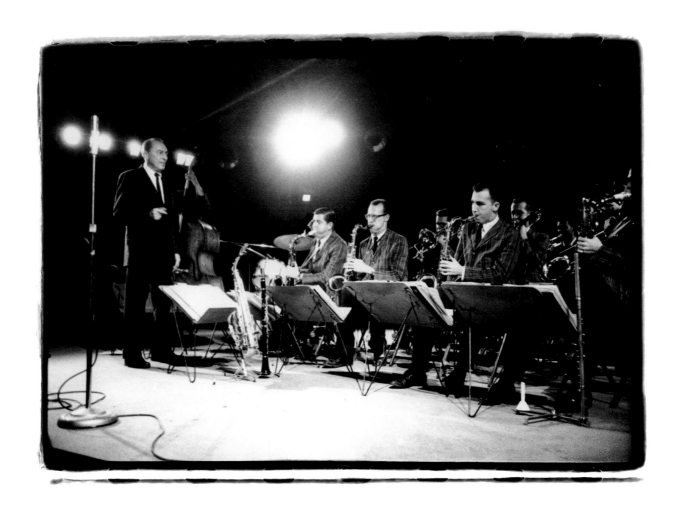

Woody Herman and the saxophone section, Beverly, MA, 1983

< Trombonist J. J. Johnson, Town Hall, NYC, c. 1960

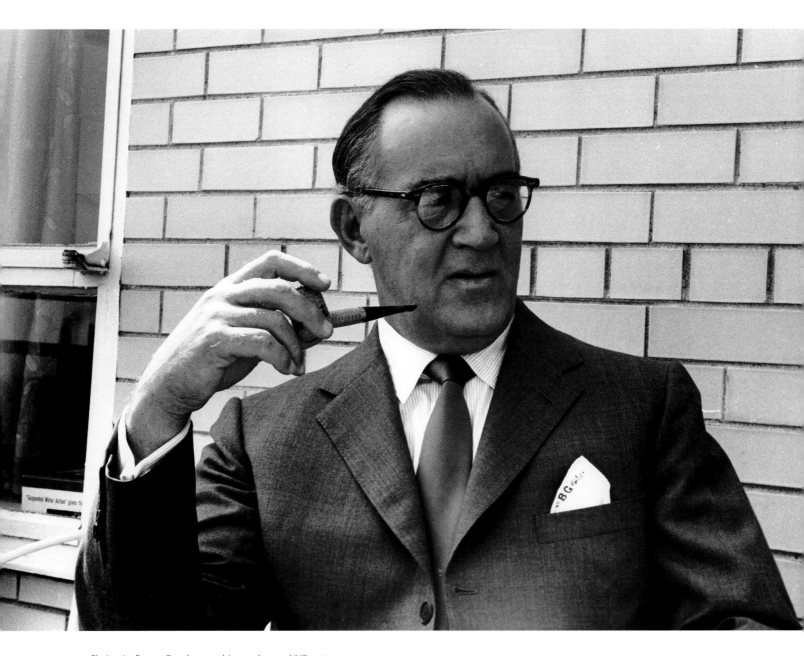

Clarinetist Benny Goodman at his penthouse, NYC, 1960

Wayne Shorter, Village Gate, NYC, 1961 >

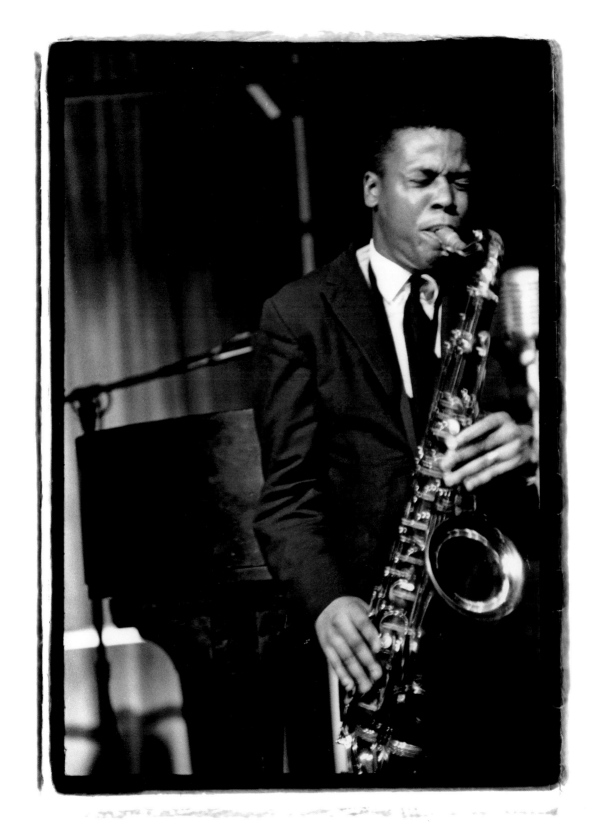

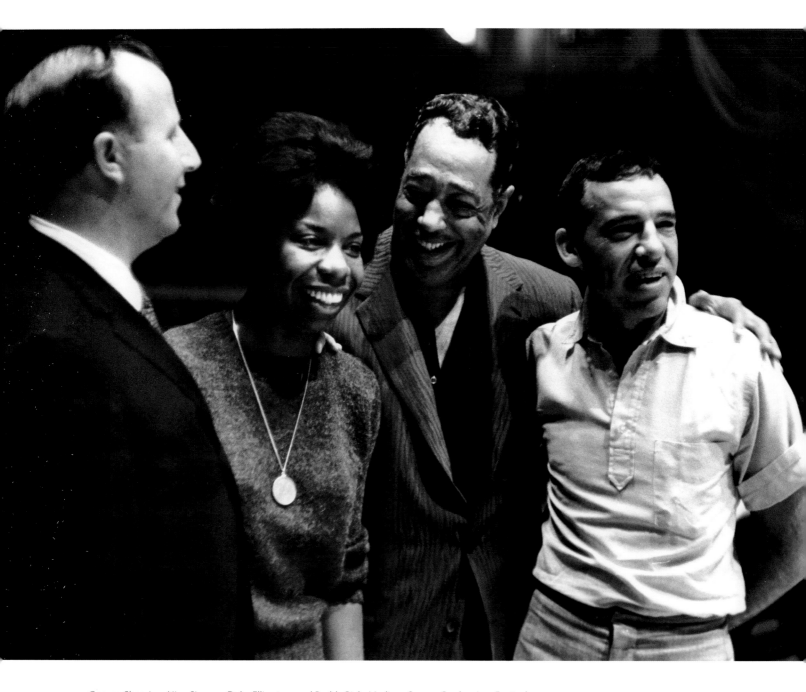

George Shearing, Nina Simone, Duke Ellington, and Buddy Rich, Madison Square Garden Jazz Festival, 1959

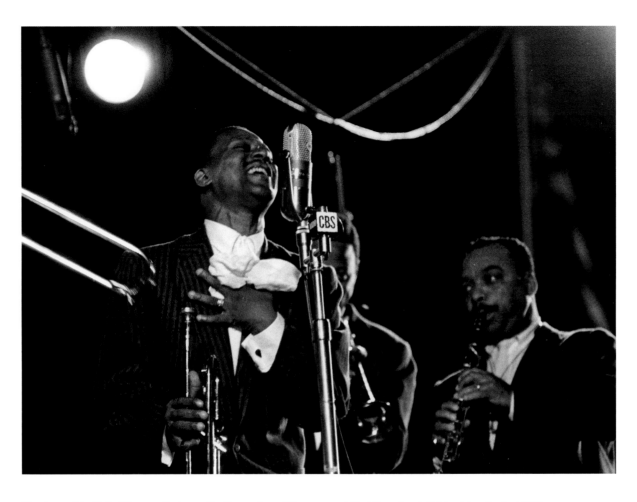

Members of the Duke Ellington Orchestra Ray Nance, Russell Procope, and Clark Terry, Randall's Island Jazz Festival, NYC, 1959

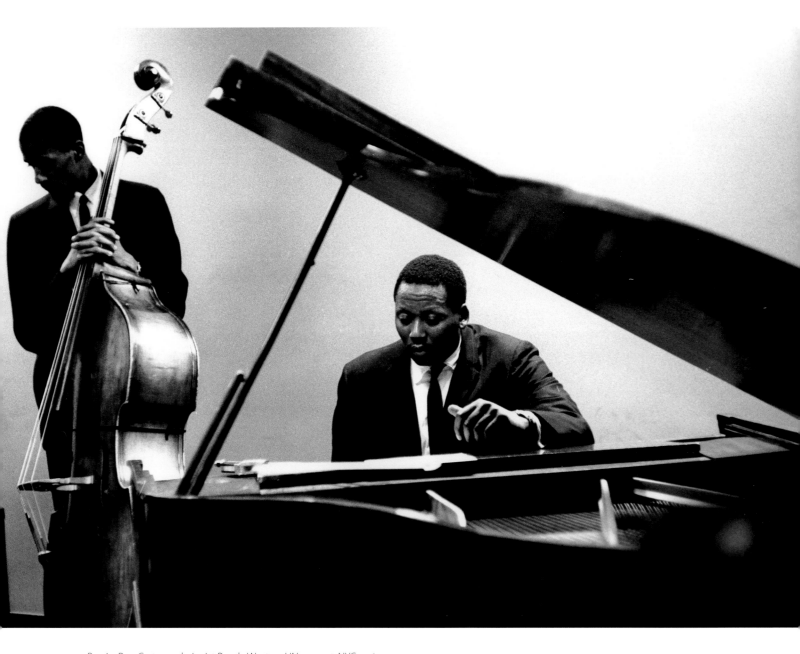

Bassist Ron Carter and pianist Randy Weston, UN concert, NYC, 1961

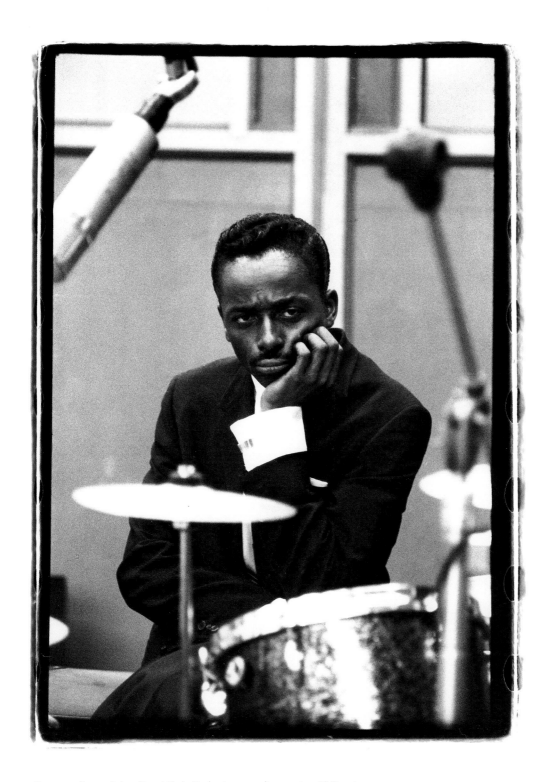

Drummer Sonny Paine, Count Basie Orchestra recording session, NYC, 1960

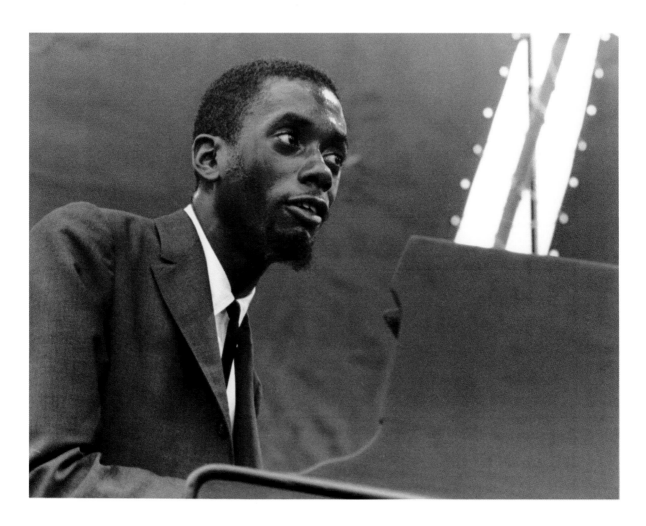

Pianist Bobby Timmons, Randall's Island Jazz Festival, NYC, 1959

Benny Carter, Harvard College, Cambridge, MA, 1988 >

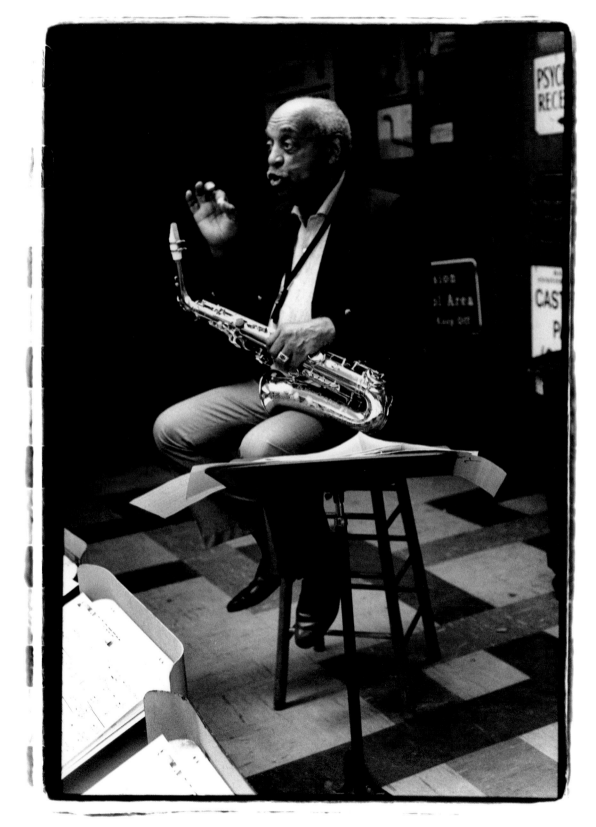

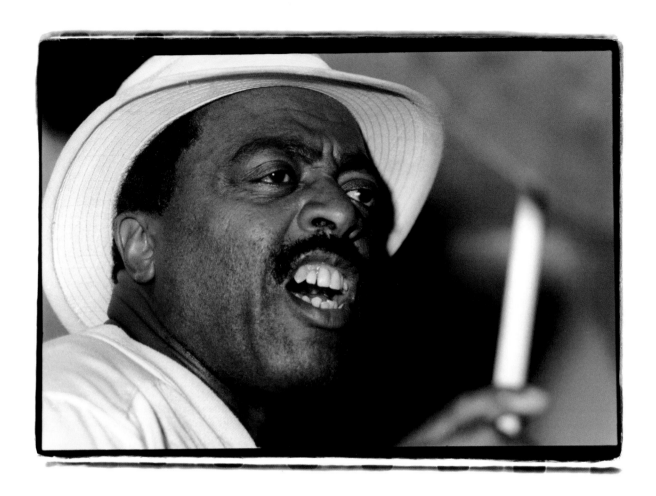

Drummer Roy Haynes, Cambridge, MA, 1986

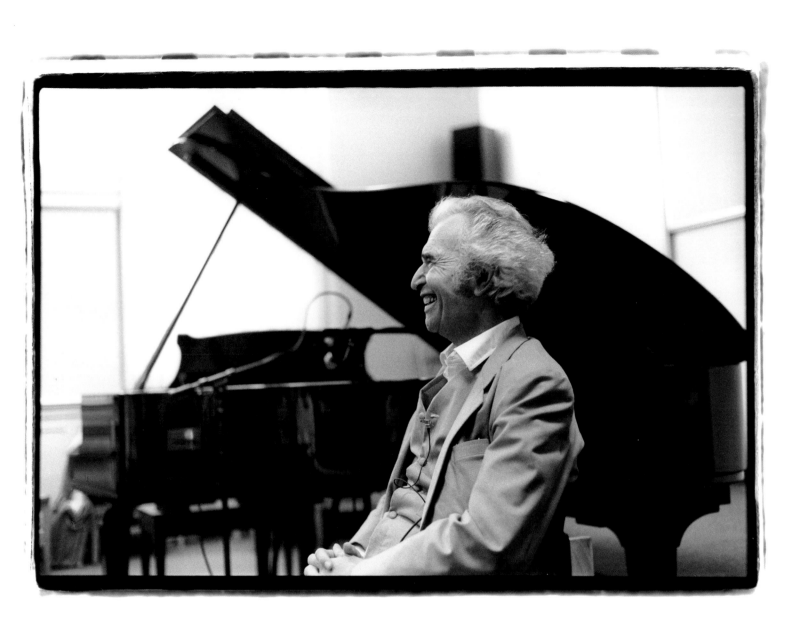

Pianist Dave Brubeck, Harvard College, Cambridge, MA, 1986

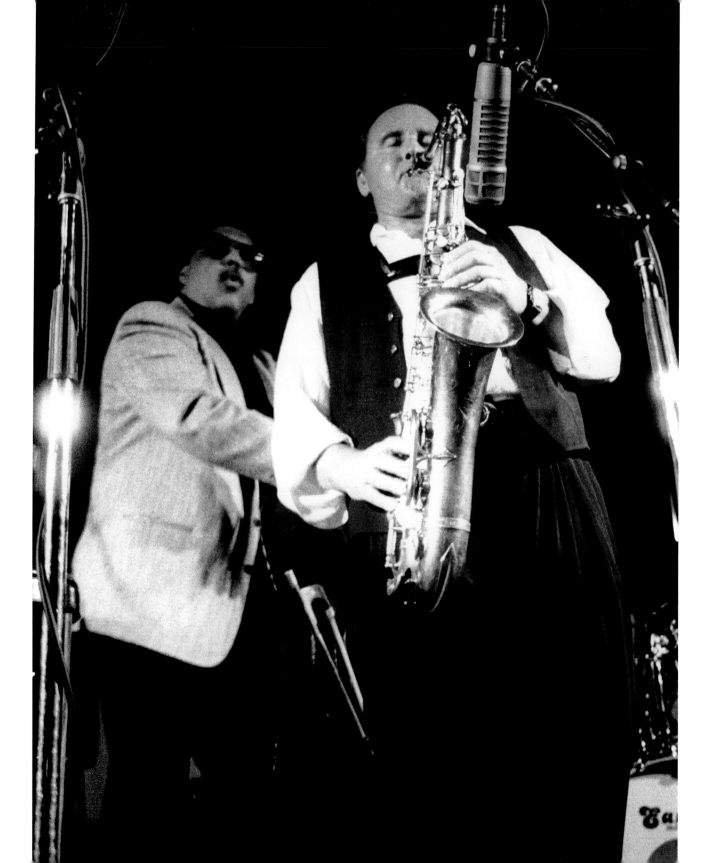

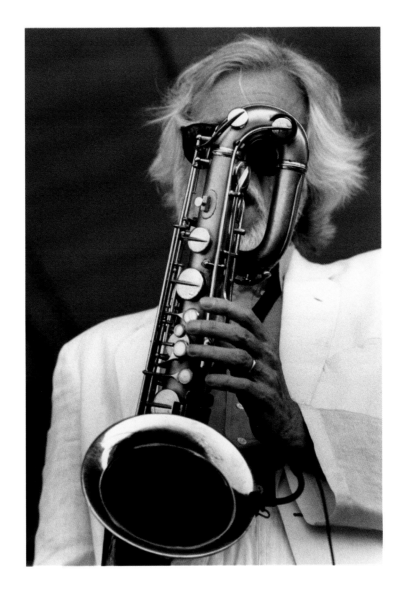

Saxophonist Gerry Mulligan, Newport Jazz Festival, Newport, RI, 1990

< Saxophonist Stan Getz and bassist Rufus Reid, Cambridge, MA, 1990

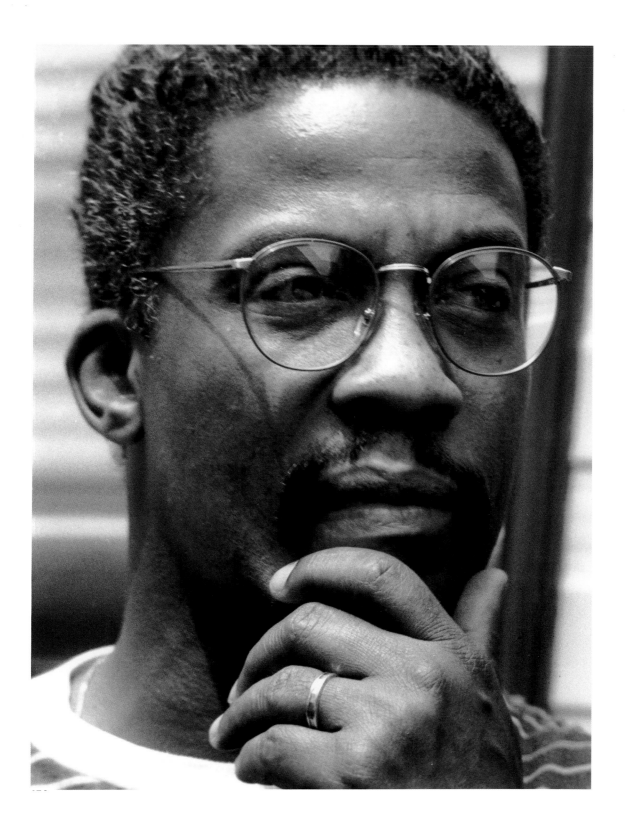

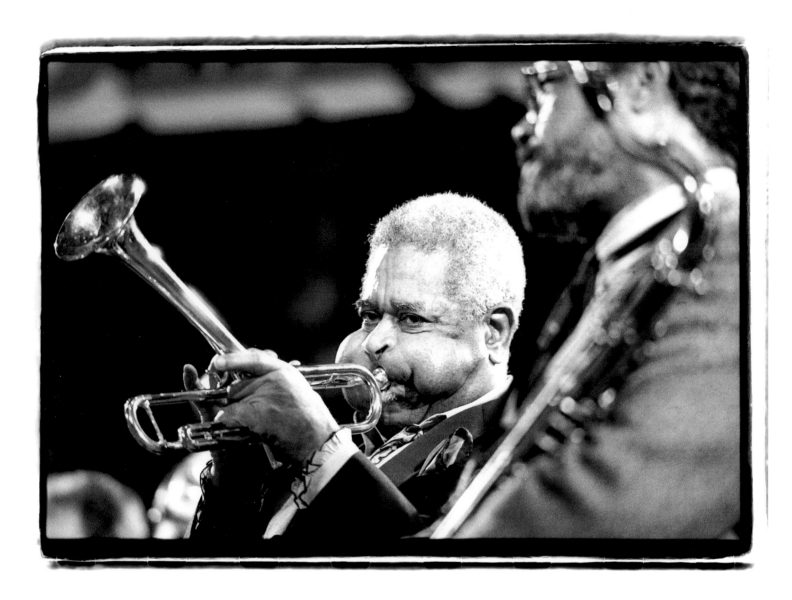

Trumpeter Dizzy Gillespie with saxophonist Clifford Jordan, Bern International Jazz Festival, Switzerland, 1988

< Pianist Herbie Hancock, Newport Jazz Festival, Newport, RI, 1988

Sonny Rollins, Boston Globe Jazz Festival, Boston, MA, 1990

< Sonny Rollins, Boston Globe Jazz Festival, Boston, MA, 1990

Trumpet player Lester Bowie and friend, Cambridge, MA, 1986

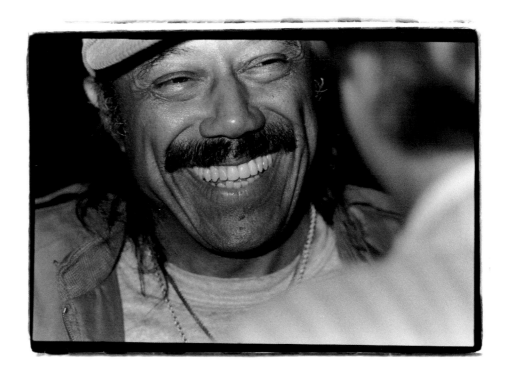

Pianist Horace Silver, Bern International Jazz Festival, Switzerland, 1987

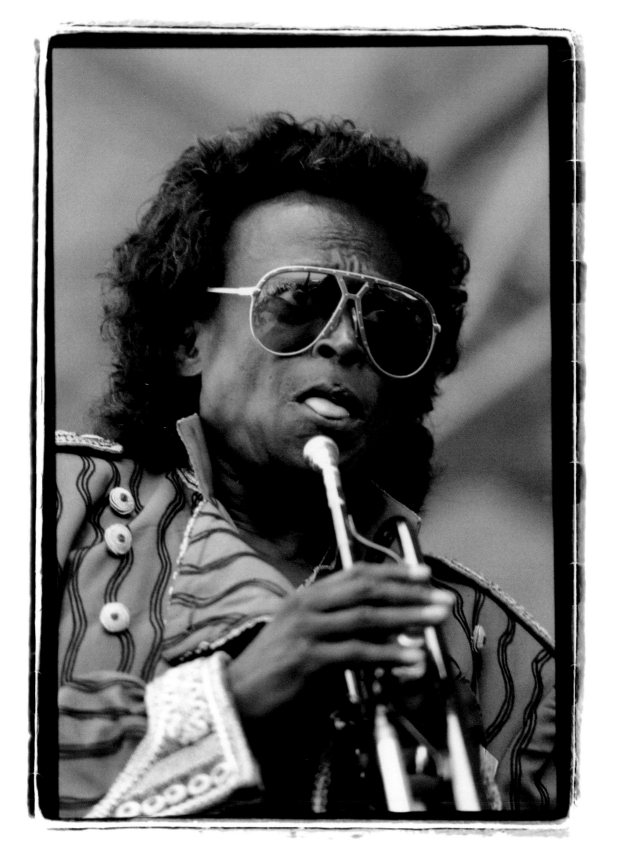

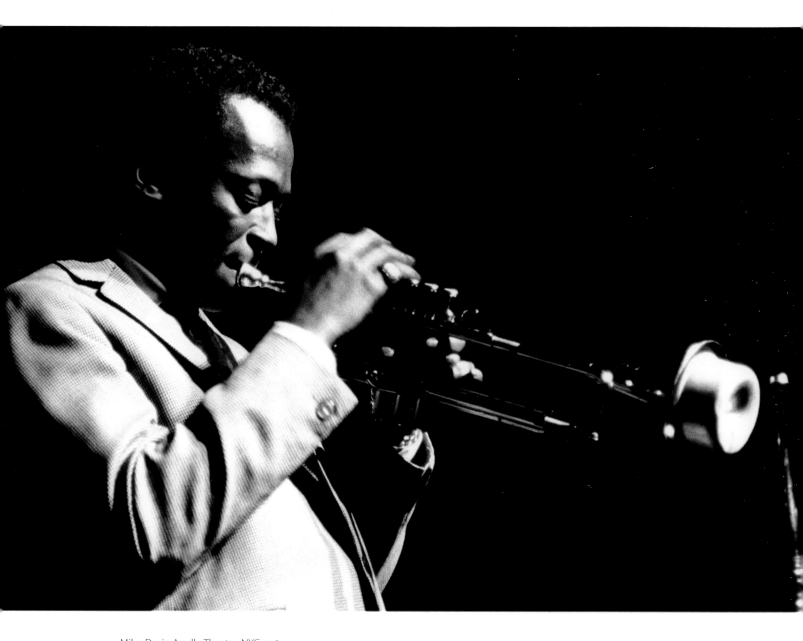

Miles Davis, Apollo Theatre, NYC, 1960

< Trumpet player Miles Davis, Newport Jazz Festival, Newport, RI, 1990

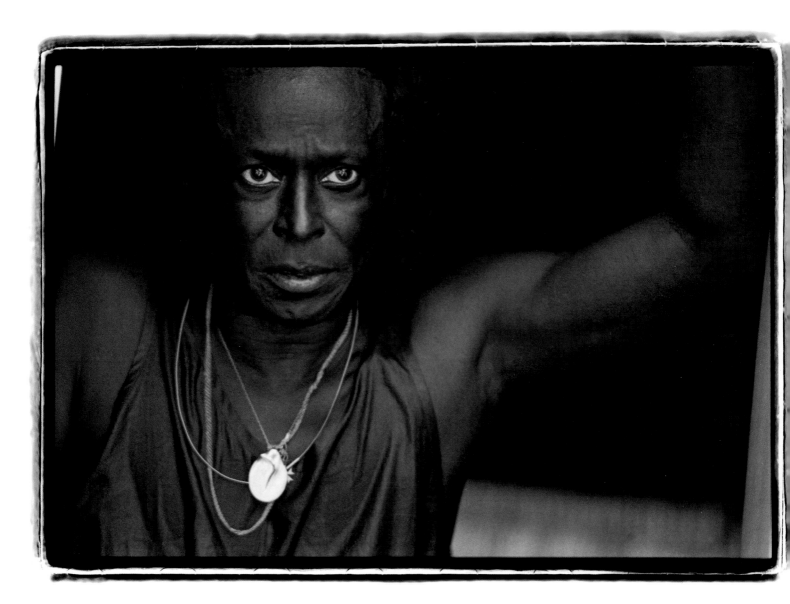

Trumpet player Miles Davis, Newport Jazz Festival, Newport, RI, 1990

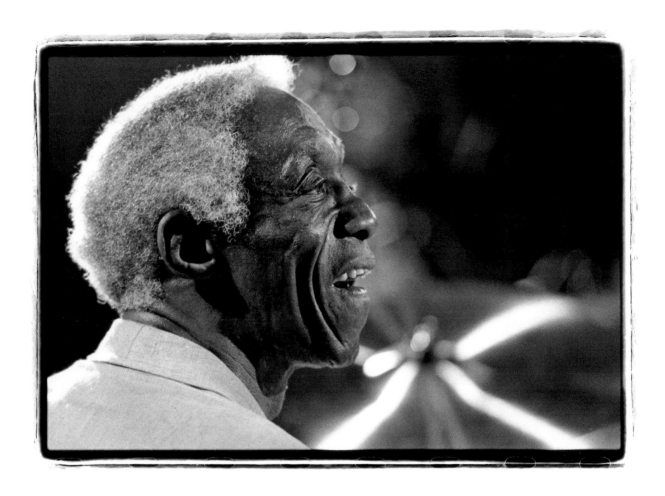

Drummer Art Blakey, Bern International Jazz Festival, Switzerland, 1989

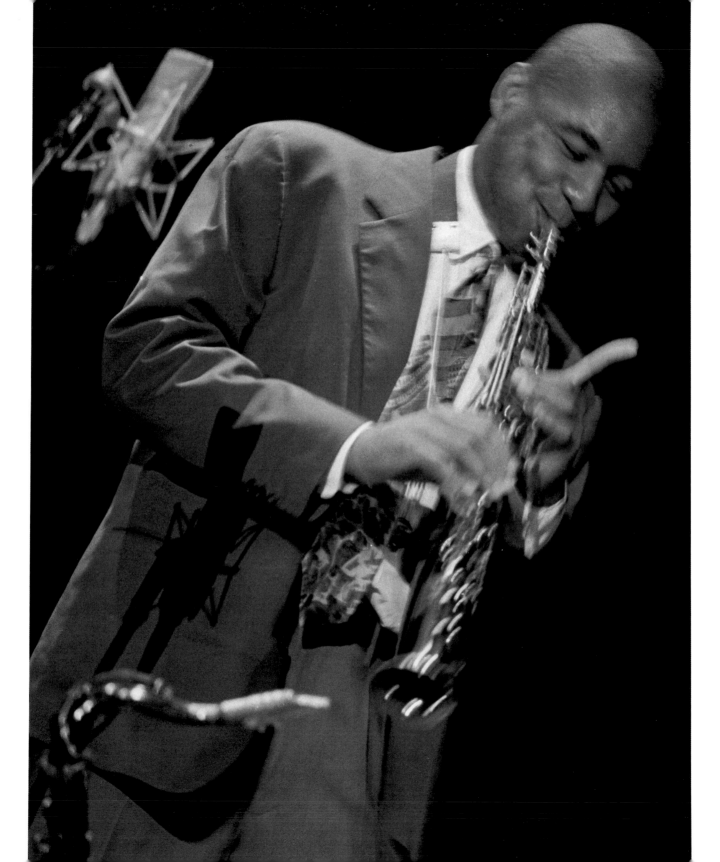

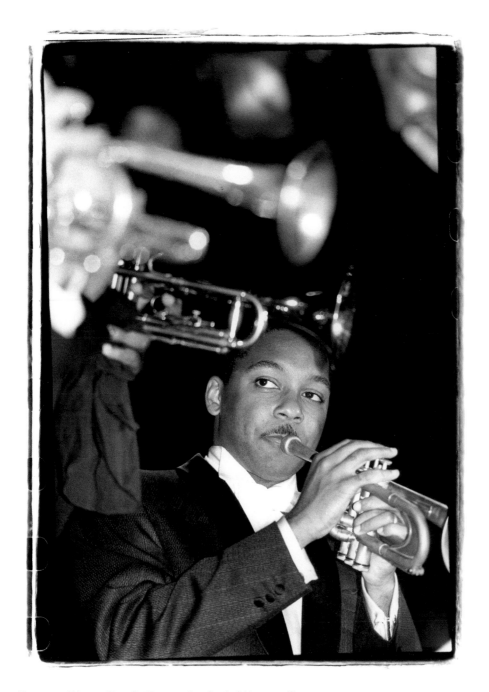

Trumpeter Wynton Marsalis, Newport Jazz Festival, Newport, RI, 1990

< Soprano Saxophonist Branford Marsalis, Boston Globe Jazz Festival, Boston, 1991

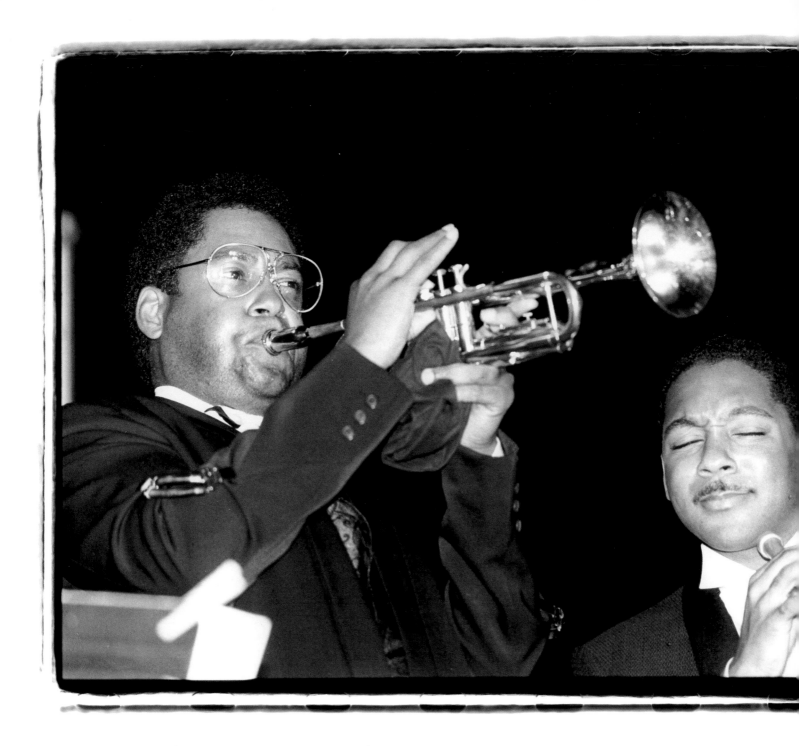

Trumpeters Jon Faddis & Wynton Marsalis, Newport Jazz Festival, Newport, RI, 1990

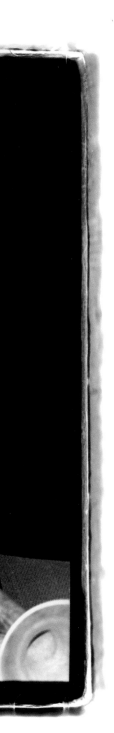

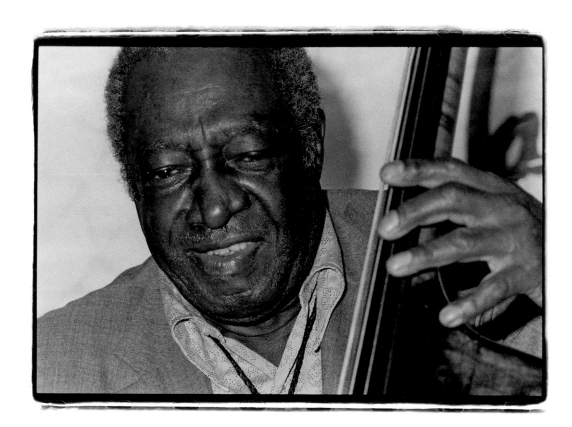

Bassist Milt Hinton, Bern Jazz Festival, Switzerland, 1989

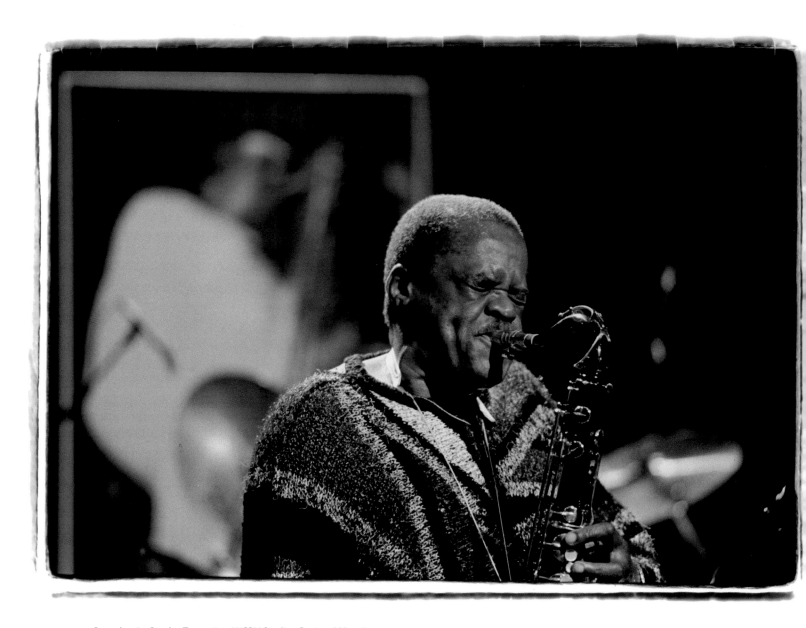

Saxophonist Stanley Turrentine, WGBH Studios, Boston, MA, 1989

Bassist Percy Heath of the Modern Jazz Quartet, Boston, MA, 1982 >

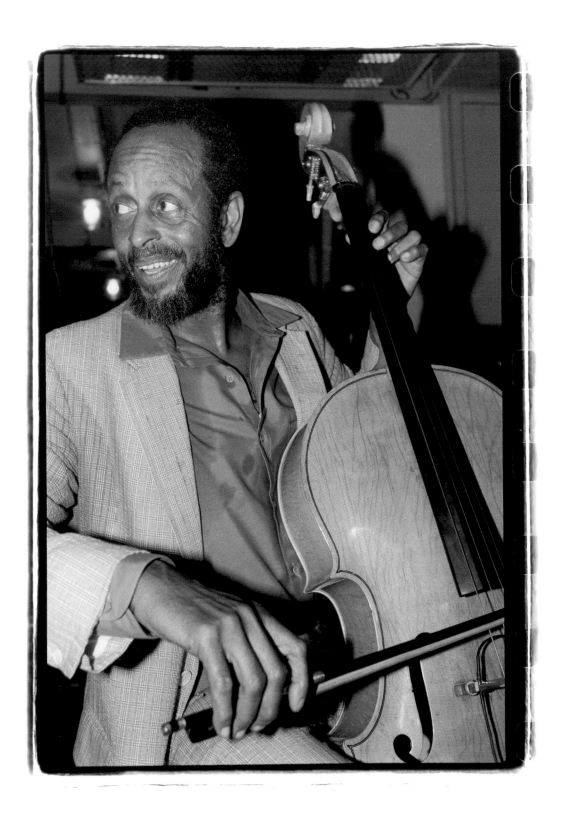

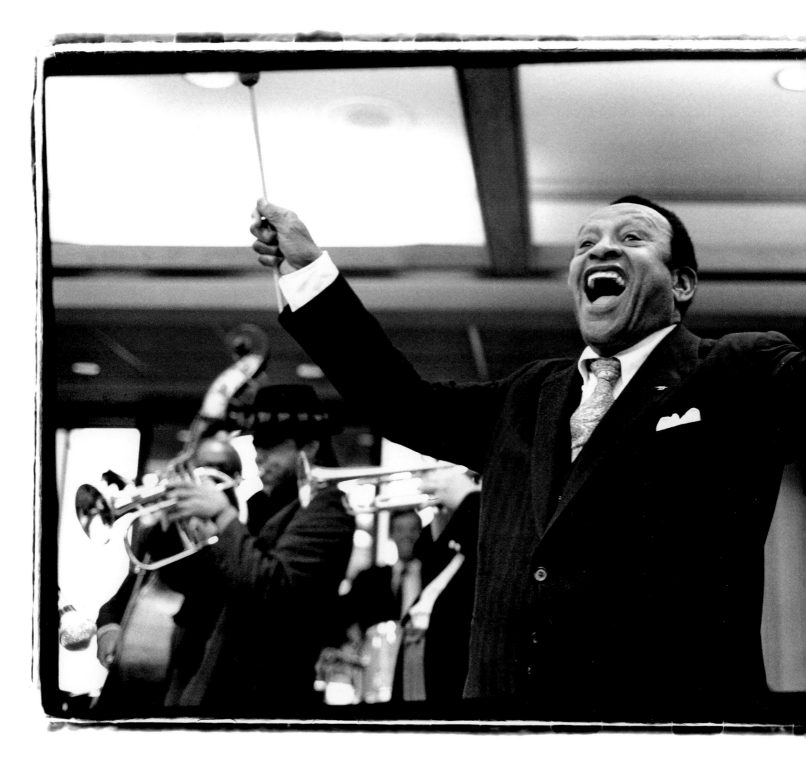

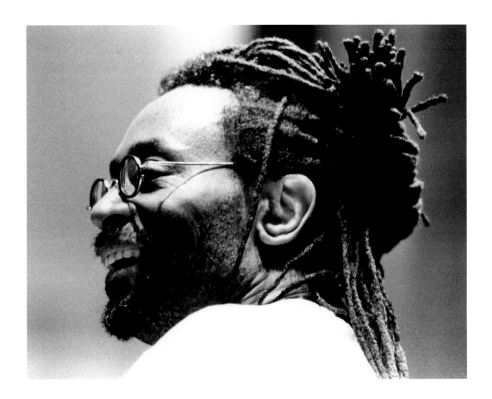

Singer Bobby McFerrin, St. Petersburg, FL, 1996

< Lionel Hampton and Chuck Mangione, "Windows of The World
Restaurant," World Trade Center, NYC, 1989

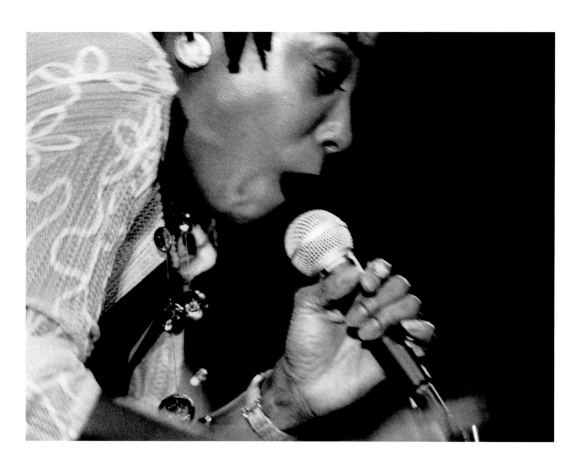

Singer Dee Dee Bridgewater, Tampa, FL, 2000

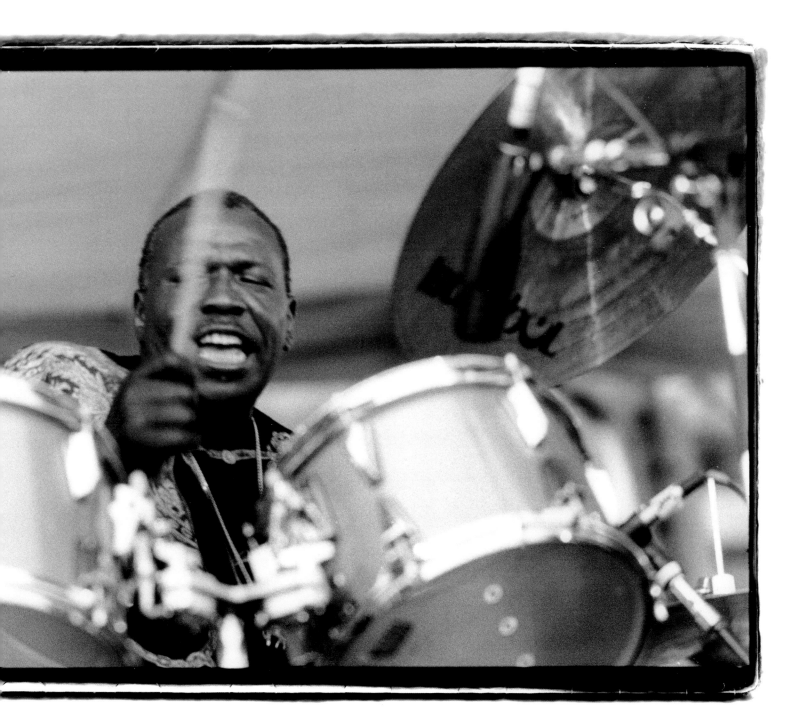

Drummer Elvin Jones, Newport Jazz Festival, Newport, RI, 1990

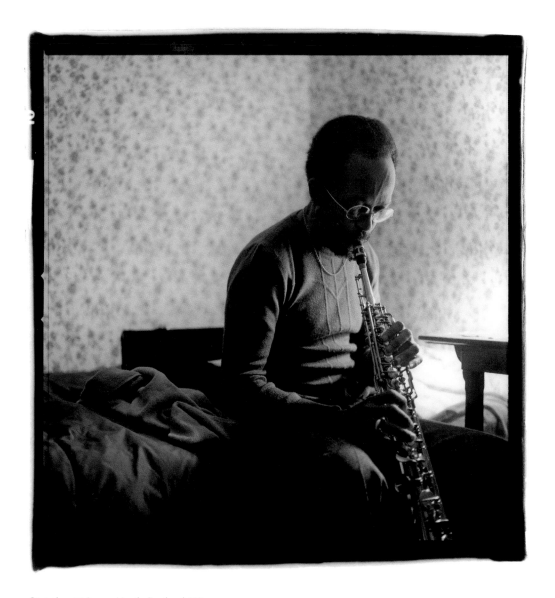

Saxophonist Jimmy Heath, Portland, ME, 1977

Pianist Hank Jones, Bern Intl Jazz Festival, Switzerland, 1989 >

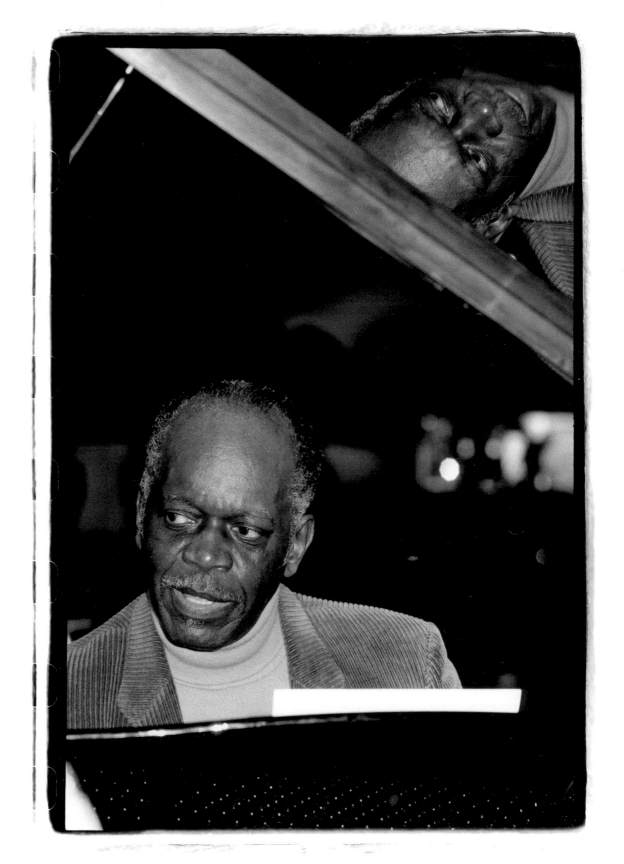

Afterword

The State of Jazz

By Dan Morgenstern

(This editorial, written by Dan Morgenstern, the director of the Institute of Jazz Studies at Rutgers University and the most important jazz historian living today, was published in 1960 in *Metronome* magazine, and it is applicable today.)

A fresh wind is blowing from Washington these days. After long years of slumber and inertia, straight talk and direct action are once again the order of the day. While there was no mention of jazz in J.F.K.'s State of the Union message, it is time for jazz, too, to wake up. Jazz, after all, is American music and has throughout its history mirrored and reflected America's conscience and consciousness.

Is the House of Jazz in good shape? On the one hand one hears more talk, reads more print and sees more images of jazz today than ever before. On the other hand, there are fewer jobs, bands, and less security in jazz today than twenty-five years ago. Sure, there are more records, there are the festivals, and there are the overseas junkets, sometimes sponsored by the State Department. And lots of people talk long and loud about jazz as an art form, as if this were a record development. But you can't eat words or live on dreams, and the sad fact of the matter is that jazz is still a minority music. Rock and Roll, pronounced dead over and over again, is still alive and kicking. Lawrence Welk is still making bread. And the rich foundations and civil organizations are still sustaining symphony orchestras and classical music and throwing crumbs to jazz.

The jazz musician may believe himself to be an artist, but when he's on the road or on the job in a club, he is still the number one victim and scapegoat among American performers—at the mercy of every ignorant cop throughout the country. And the old good feeling that existed among jazz people not so long ago, and was to them a source of strength and a much needed escape valve—that, too, is almost gone. Everybody is unhappy with the status quo but what is being done about changing things?

There are those in jazz who are strong enough and resourceful enough to go their own way, and get along. But that is not enough. What is urgently needed in the world of jazz today is a stronger bond between its various elements. Between musician and musician, regardless of "school" or generation; between musician and promoter; between musician and club owner; between musician and "critic" (or as we prefer to think of ourselves here at *Metronome,* jazz reporters and writers); between musician and recording director—and between musician and audience. Everybody has been at fault. Every group has its percentage of jive talkers and thieves as well as men of good will. (Yes, Virginia, there are decent bookers and club owners.) Looking out for oneself first may be a sound rule, but it has its limitations. No one today seems to trust anyone else; making a fast buck and splitting the scene is the order of the day. Yet, all of us connected with jazz have essentially the same problems and aspirations. The situation today benefits no one in the long run. If it did, it would be logical and efforts could be devoted to dislodging the top dog. But there ain't no such animal. Today's high-priced top act is tomorrow's pavement pounder. The musician

who disdains applause today will yearn for it tomorrow. The operators who clean up without regard for the future soon start crying about the fickleness of the jazz audience. Many, far too many, of the people involved in jazz believe that everything is for sale—an attitude which cheapens and dishonors the music and its true creators and friends. The few who are, and have been for sale, are the exceptions, not the rule. They are not the trouble—the trouble is the lack of communication within jazz which prevents our effective communication with the world.

Jazz, it has been rightly said, is music that tells a story. Yet the true stories of jazz rarely see the light of day or come out distorted, partial, or propagandistic. One of the saddest experiences we've had in years was viewing a film which calls itself the *Cry of Jazz*. To anyone who knows jazz, the absurdities of this film soon become apparent, and it will make scant impression on any but the most misguided, bitter, and immature musician or fan. But to people who know nothing about jazz, this film will act as a powerful appetite suppressant. It is an infantile, amateurish, and prejudiced concoction, but it has been allowed even among literate people to represent a jazz point of view. It is time that all of us who care about jazz got together and as Buddy Bolden said, "Open up the windows and let the foul air out." Jazz is far too important and beautiful a music to let itself be victimized needlessly by greed, arrogance, over-hipness, and thoughtlessness.

As far as *Metronome* is concerned, we could wish for nothing more than to become a sounding board for the gripes, grievances, and grudges which beset all facets of the jazz world—not to publicize and perpetuate dissention, but to prove we all share common problems and that they are anything but impossible to solve. Jazz is the music of freedom, but in order to be free, we must be together. Together we can build for jazz the respect and consideration American's only indigenous art form so well deserves and so sorely needs. Together we can build a home of jazz with solid walls and foundations. Together we can remove the injustices which impede our progress at home.

The jazz message has proven itself strong enough to capture the hearts and imagination of peoples all over the world. It is about time we brought this message fully to bear right here. But as long as we stand in our own way, nothing will be accomplished. Together we can swing—alone we will all remain hung up. The future of *Metronome* and jazz are all related. Ideas, suggestions, and criticism from all the many corners of jazz will be most welcome. Let's do something for jazz.

Jazz Glossary

No book relating to jazz and the "jazz-life" should be absent of a jazz glossary.

Ax—any musical instrument, even a piano.

Bad—good. An example of the perverse strain in jazz slang by which antonyms are put to use as synonymous. "He blows bad piano, man" is therefore an expression of great approval.

Ball—a good time. Also, sexual intercourse.

Benny—overcoat.

Blow—to play a musical instrument.

Bread—money.

Bring down—to depress; to sadden.

Bug—to annoy.

Cat—male, hipsters and squares alike.

Chips—girls, chicks.

Chops—lips.

Cool—approval and appreciation.

Crazy—good, excellent, exciting, stimulating.

Cut—to outdo another, to play better.

Dig—understand, appreciate, enjoy.

Drag—to annoy, disturb, harm.

Eyes—appreciation, "I've got eyes for that."

Fall in—to arrive, to enter.

Far out—extremely advanced.

Flip—to become excited.

Flips his wig—becomes excited.

Fuzz—police.

Gig—work, professional engagement.

Goof—to fail.

Groovy—approval, fashionable.

Hip—worthiness, cool, knowing.

I feel a draught—someone doesn't like me.

Jam session—musical gathering, usually improvised.

Kicks—fun, enjoyment.

Man—varies with content; greatly dependent upon inflection, usage.

No eyes—no appreciation at all.

Ofay—black slang meaning white person.

Pad—home or apartment.

Put down—to deride, criticize.

Rock—to dance, to sway with the music.

Rug—to dance, to frolic, to cut a rug.

Scat—to improvise while singing.

See—to read music.

Short—automobile, wheels, rubber.

Solid—approval.

Split—to leave.

Square—generally unworthy, classical music; one who is unworthy.

Stud—male.

Swing—to play well; to do anything well, creative, cool.

Tub—a cool person (not really in use today).

Wail—to play very well, do anything well.

Zoot—popular in the forties, zoot-suit.

Zorch—used for almost anything: saxophone, book, very obscure.